IMAGES
of America
APACHE TRAIL

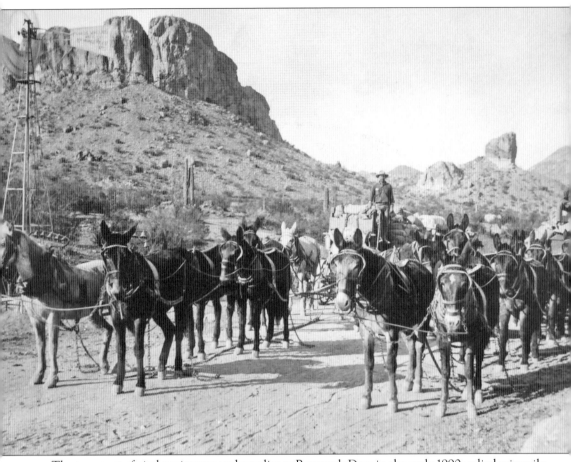

The transport of vital equipment and supplies to Roosevelt Dam in the early 1990s relied primarily on the freighters who used teams of horses and mules to pull their cargo on wagons. The teamsters provided critical transportation services for many years. According to Earl A. Zarbin in his book, *Roosevelt Dam: A History to 1911*, "by September 1905, teamsters hauled 1,500,000 pounds of freight per month to Roosevelt." (Courtesy Bureau of Reclamation, Walter J. Lubken Collection.)

ON THE COVER: This motorist appears to reach the end of the road and decides to stop, enjoy the view, listen to the roaring water, and ponder the meaning of life around 1909. This image appears in an old Southern Pacific Railroad bound book of photographs titled *Apache Trail of Arizona*. There is no publication date on this book; it was produced in both black and white and color versions. (Courtesy SMHS, Southern Pacific Railroad photograph book.)

IMAGES of America
APACHE TRAIL

Richard L. Powers,
the Superstition Mountain Historical Society,
and the Gila County Historical Society Museum

Copyright © 2009 by Richard L. Powers, the Superstition Mountain Historical Society, and the Gila County Historical Society Museum
ISBN 978-0-7385-5862-2

Published by Arcadia Publishing
Charleston SC, Chicago IL, Portsmouth NH, San Francisco CA

Printed in the United States of America

Library of Congress Catalog Card Number: 2008932143

For all general information contact Arcadia Publishing at:
Telephone 843-853-2070
Fax 843-853-0044
E-mail sales@arcadiapublishing.com
For customer service and orders:
Toll-Free 1-888-313-2665

Visit us on the Internet at www.arcadiapublishing.com

I dedicate this book to my family and friends who encouraged me to follow my dream of sharing the history of the Apache Trail.
To my wife, Lee Ann, and my sons Richard II and Ryan for their support, understanding, and encouragement.
My late father, Robert Lee Powers, and my mother, Kathy, encouraged me during my formative years.

Contents

Acknowledgments		6
Introduction		7
1.	Birth of Roosevelt Dam and the Apache Trail	11
2.	Early Days of the Apache Trail	35
3.	Public Use and Sunday Drives	59
4.	Tourist Destination Apache Trail	79
5.	A Period of Change	95
6.	Modern-Day Apache Trail	111
Bibliography		127
About the Author		127

Acknowledgments

Special thanks to my wife, Lee Ann, for her tremendous support, encouragement, and assistance. The Superstition Mountain Historical Society (SMHS) provided a majority of the photographs and was available at all hours of the day and night; Gregory Davis provided access to their collection of photographs, books, brochures, publications, newspapers, maps, postcards, and memorabilia and assisted in review of the captions. Jon Czaplicki from the U.S. Bureau of Reclamation Phoenix Area Office provided many pictures, primarily from the famous Lubken Collection, and assisted with the captions. The Gila County Historical Society Museum (GCHSM) provided several pictures and information; Bill and Lynn Haak were very supportive, provided access to the museum's photographic collection, and assisted with editing the text. Shelly Dudley and Ilene Snoddy from Salt River Project (SRP) were very helpful, provided several photographs, and assisted with captions. Terry Brennan of the Tonto National Forest provided encouragement to study the historical features of the Apache Trail. Michael Sullivan, also with the Tonto National Forest, provided significant historical background, pictures, maps, documents, and historical information; he also edited the text for accuracy and content. Stan Gibson, former mayor of Globe, provided several photographs and assisted with the writing of their captions. Angela Antilla provided vintage WPA photographs, and Jodi Akers provided a rare photograph. George "Butch" Trojanovich, former maintenance foreman for the Apache Trail, provided several pictures, stories, and information. Pat H. Stein's extensive research for ADOT on the historical context of the Apache Trail provided valuable dates, facts, and information. Vicki Bever, Ed Green, Irene Steffen, Bob Gasser, Ronnie Speer, and Tom Kent of the Arizona Department of Transportation (ADOT) graciously provided images and information. Steve Thomas of Federal Highway Administration (FHWA) Phoenix Office provided historical information. Ingo Radicke, former ADOT Transportation Board chairman, provided several photographs. Others who have assisted along the way include my friends and colleagues at ADOT, FHWA, Tonto National Forest, Globe-Miami Regional Chamber of Commerce, consulting engineering firms, American Council of Engineering Companies (ACEC) of Arizona, American Public Works Association (APWA), and many others; all encouraged my historic research pursuits. The Arizona Historical Society Museum at Papago Park provided me access to their Apache Trail exhibit to take photographs of the zero mile marker.

Jared Jackson, the Southwest acquisitions editor for Arcadia Publishing, provided all the resources needed to complete this publication; even with an aggressive production schedule, he was always supportive.

Introduction

The Apache Trail, located in central Arizona, is one of the most picturesque, well-known roads in America, if not the entire world.

The history of the trail, which follows the Salt River from central to eastern Arizona, dates back to prehistoric times, long before the route was given its famous name "Apache Trail." The Salado tribe used this route around AD 900. Before that, it is believed the ancient foot trail was used by the Anasazi (Ancestral Pueblo) tribes coming from the Tonto Basin area to trade with the Hohokam. Other Native Americans may have used the trail as a migratory route between their winter homes in the desert and summer homes in the mountains. The foot and horse trail along the Salt River was called the Tonto Trail and has also been referred to as the Yavapai Trail.

The real story of this famous road begins with the need for a reliable water supply for the Phoenix metropolitan area in the late 1890s and early 1900s. Farming was a big part of the early frontier life. The area was experiencing an extended drought, causing a critical situation that threatened the mere existence of these hardy pioneers. A group of settlers in the Salt River Valley formed an organization called Salt River Valley Water Users Association, a group that still exists today, who pledged their land as collateral for a government loan to build a new dam. Membership in this organization is made up of landowners in the Salt River Reservoir District; the association was incorporated in 1903. This organization was led by a group of influential and tenacious men who lobbied Congress and the president for government funds to construct the dam and canal system. Their goal was to have a reliable water source for their land during periods of drought and protection for their land during flooding events. A dam would meet both goals. All their hard work finally paid off on June 17, 1902, when Pres. Theodore Roosevelt signed into law the National Reclamation Act, which provided government loans to "reclaim" the arid West through irrigation projects. One of the first major western projects undertaken was construction of Tonto Dam (later called Theodore Roosevelt Dam) just below the confluence of Tonto Creek and the Salt River in central Arizona.

In order to facilitate construction of this massive dam, a supply road was needed to transport the materials, equipment, and resources to the work site. Arthur P. Davis, U.S. Bureau of Reclamation's chief engineer, evaluated two possible routes for a wagon road from established railheads to the construction site. Both alternatives traversed extremely mountainous terrain and provided unique engineering challenges. One option was to upgrade the existing trail from Globe; the other was to construct a new road from Phoenix through Mesa to the dam site. Mesa is located approximately 60 miles southwest of the dam site and offered the advantage of two railroad connections. Globe, located approximately 40 miles southeast of the dam site, connected to only one remote railhead. The Globe alternative was initially preferred since a serviceable wagon trail already existed that had been used since the 1880s. Although this road was primitive, winding, and sometimes treacherous, Davis estimated it could be upgraded and shortened from 43 miles to 39 miles for approximately $6,000, according to the *Arizona Republican* on September 2, 1903. Improvement work on the Globe road began in December 1903 and was completed in May 1904. The Highline Road to Globe, as it was called at that time, facilitated delivery of the earliest supplies to the project site. Reclamation continued to analyze the feasibility of building a road from Mesa. In 1903, the U.S. Geological Survey, Reclamation's parent agency during the early 20th century, utilized

the survey data obtained to compile an initial reconnaissance map of the route. Mesa's two rail connections meant competitive freight rates and direct cost savings to the project. Comparison of freight rates showed a savings of $15 a ton by transferring freight through Mesa instead of Globe. Since freight charges would account for much of the final cost of the dam, and since the first 22 of the 60 miles from Mesa to the dam site were relatively level, Reclamation decided to build "a first-class freight road" to the project site, according to the *Reclamation Record* in June 1914 (Volume 5, No. 6). The estimated cost of building the road would be expensive and would range between $150,000 and $200,000.

In 1903, Reclamation assigned a grading crew to work on the proposed road in the vicinity of Goldfield. Reclamation halted the construction work until additional money could be dedicated to the project. During 1903 and 1904, the route was partially resurveyed and a telephone line to the dam site was proposed. By November 1903, additional funding was secured through bonds posted by the cities of Phoenix, Mesa, and Tempe. Construction resumed on the telephone line and road work. The road was originally called the Tonto Wagon Road and later the Phoenix-Roosevelt Road and the Mesa-Roosevelt Road and Ocean to Ocean Highway between 1903 and 1915. Early discussions regarding ownership of the road upon completion were initiated in the spring of 1904. Initial agreement was that Reclamation would own and maintain the road as long as it was needed for the dam construction. Following completion of the dam, ownership would revert to the Salt River Valley Water Users Association. By mid-June 1904, several hundred men were working on the construction of the road. Most of the work was done by hand using rudimentary construction methods; very little was done with mechanized equipment. Reclamation built the road itself and did not contract out any of the work. The workforce was largely Native American workers; approximately half of laborers were Apache tribal members from the nearby San Carlos Reservation. Several work crews were led by Al Sieber (chief of scouts), as a 1914 Reclamation article stated:

> The trail up Fish Creek Hill, which later became the most picturesque part of the [Mesa-Roosevelt] road, was first made possible for horses by Al Sieber, U.S. Scout, and a Troop of the 4th Cavalry in 1873, when following a band of hostile Indians from upper Salt River. The Indians crossed to the north side of Salt River on the riffle at the mouth of the sand wash where the Roosevelt Road strikes the river, seven miles below Roosevelt. The river being too high for the troops to cross with their pack train, they continued down the south side of the river, spending three days' labor on Fish Creek Hill before they succeeded in getting their animals out of the canyon. All the mucking and shovel work on the road was done by Apache Indians, working under their chiefs. Later these Indians developed into valuable laborers and were used in the maintenance work on the road during the building of the Roosevelt Dam.

By 1904, government employees were using the uncompleted road to reach the dam construction site. According to the *Arizona Republican* on April 14, 1904, the Bowen and Grover stage line carried them from Mesa to Mormon Flat, where they switched to mules for the remainder of the trip.

Reclamation work crews were based at a series of construction camps along the route, according to the *Arizona Republican* on August 24, 1904. Camps were named after the foremen in charge. Botticher's Camp was located about one mile below the dam site, Harpham's Camp was about 10 miles below Roosevelt, Fitzgerald's Camp was near the bottom of Fish Creek Hill, and Thompson's Camp was at the top. Harbin's Camp was between Fish Creek and Mormon Flats Camps, and at Mormon Flat was the Utting camp. Crews realigned and upgraded road segments almost as soon as they were completed. According to the *Arizona Republican* on July 10, during the summer of 1904, the crew from Botticher's Camp realigned the segment of the road immediately below the dam site to eliminate two river crossings and to align the road entirely along the south side of the Salt River.

By early October 1904, the road was nearly completed. The road required bridges over Lewis and Pranty Creek, Fish Creek, and Ash Creek. The Fish Creek Hill section also remained to be completed. Government officials had concerns about the difficulty and construction costs of the steepest portion of the road, as described below in a Reclamation Service report:

> The road climbs the hill going towards Mesa on a 10 percent grade, for the most part along the foot of a vertical cliff several hundred feet high, the cliff being so steep as to necessitate rock fills seventy-five feet in height in order to get the required width of roadway. In other places, rock cuts sixty to seventy feet in depth were necessary. Some short sections of the road were very expensive to construct, the cost probably reaching $25,000 or more per mile.

By early December 1904, a stagecoach line carrying both mail and travelers made the trip between Mesa and Roosevelt in one day using three changes of horses, according to the *Arizona Republican* on December 6, 1904. Stations were developed along the route to support the stage operation and to allow travelers a place to rest. The Bowen and Grover stage line constructed a roadhouse at Mormon Flat, and other stations were developed at Desert Wells, Goldfield, and Weekes Ranch a mile east of Goldfield, Government Well, Mormon Flat, Tortilla Flat, Fish Creek, and Davis Wash, reported the *Arizona Republican* in April and May 1904.

The road was in good enough condition to be used for heavy hauling by early 1905. The original road terminated not at the dam site but several hundred feet east of it, near the site of the old concrete mill. The original section of road between the dam site and the mill ran along the river bottom and was subject to flooding. In January 1905, construction began on a new alignment above the future lake's high-water line that would not be subject to flooding.

An *Arizona Republican* writer, after he made the journey along the Mesa-Roosevelt Road, had this to say in early 1905:

> The wagon road of America, an indescribably beautiful and grand route without rival in the U.S. . . . The timber bridges, constructed from lumber cut in the Sierra Anchas, were substantial and used at major wash crossing. Stage stations had been established and were being improved. Teams were encountered on every mile; the road needed widening at curves so that freighters could pass. Grandest of all was Fish Creek Hill, where the road followed a shelf in the cliffs, from which a stone can be tossed hundreds of feet below.

There were rumblings that automobiles would soon use the road. Teamsters were dissatisfied with this prediction, pointing out that the sharp curves, narrow width, and high embankments could cause accidents if the road were shared with motorists. The government opened the Mesa-Roosevelt Road, including the east end realignment, on April 24, 1905. The completed roadway was approximately 60 miles long and cost $350,644 to build according to Reclamation records. Although original construction of the road was complete, the future would be filled with maintenance activities, realignments, reconstruction, repairs, and other improvement activities.

Public use began soon after its completion, and several entrepreneurs provided transportation services along the road, from stagecoach to automobile excursions. Eventually entrepreneurs appreciated the unique characteristics of the road and developed tourism and marketing strategies. In 1913, the Arizona Good Roads Association published a 200-page tour book containing road maps, pictures, and tourist information for all the roads in Arizona. One of the first to capitalize on the market value of the road was the Southern Pacific Railway Company. The famous "Sunset Route" via "New Orleans to San Francisco" train service was their springboard to success. The railroad company coined the names "Apache Trail" and "Apacheland" in a 1915–1916 publicity publication promoting automobile side tours of Roosevelt Dam and the Apache Trail. The name stuck and has been used for the road ever since. The Apache Trail name designation also included the Globe-Roosevelt (Highline) Road. Additional automobile touring companies provided service along the Apache Trail during the same time period.

The Apache Trail's fate seemed uncertain when the construction of the dam was complete. Should the road be closed or even removed? Who was going to maintain the road? Who should assume ownership of the road? There was a strong desire by the public to keep the road open for passage, since at the time it was an established transportation link between the Globe-Miami area and the Phoenix area. Also motorists appreciated the scenic qualities of the road and wanted it available for public enjoyment. The question of ownership continued to loom in the air as maintenance of this road proved well beyond Reclamation's means and ability. Soon the political wrangling began. The Salt River Valley Water Users Association began to lobby the state to assume ownership since they felt the Apache Trail was a "public road." The state finally acquiesced on April 29, 1922, and assumed ownership through a quit claim deed. The quit claim deed documents included this statement from the Reclamation Service:

> In conjunction with the building of Roosevelt Dam for the Salt River irrigation project in Arizona, the Reclamation Service constructed from the town of Mesa to the site of the dam, a highway at a cost of more than $300,000. Of this amount the town of Phoenix contributed $67,000, the town of Tempe $4,000 and the town of Mesa $5,500. The Roosevelt Dam was completed in 1911, and since that time the Reclamation Service has spent very little money in the upkeep of the road. As a result, it is in very bad condition and is rapidly being abandoned as a thoroughfare. It follows what is known as the Apache Trail, and for sentimental and other reasons, there is a popular desire that the road be kept in such a state of repair as will induce the public to use it. By resolution date March 25, 1922, the board of governors of the Salt River Valley Water Users Associate recommend that this road be transferred to the State of Arizona upon the condition that the same be declared a State Highway, reserving however, the right to make changes at certain points in the road in conjunction with contemplated power development, and special rights in the use of the road. We are of the opinion that the deed and agreement are appropriate and would conserve the interests of all parties concerned.

With the execution of the quit claim deed, the Apache Trail officially became a state highway from Mesa to Roosevelt.

Following the acquisition of the trail as a state highway, significant spending for improvements was initiated by the Arizona Highway Department. The road was widened, curves flattened, and the timber bridges replaced. As news traveled about the beauty of this gorgeous road, traffic increased and so did the need for even more improvements. Expenditures became so great as to prompt the establishment of the State Highway Commission, now the Arizona State Transportation Board, to monitor roadway expenditures throughout the state on all roads. Concerns regarding expenditures on the Apache Trail reached the highest levels of government when the eighth state legislature required a complete report be submitted in 1927. The Apache Trail, not further improved to high-level state highway standards, went into a period of oblivion as interest waned and state expenditures on the road declined. Not until between 1949 and 1961 were segments of the Apache Trail widened and paved to accommodate increasing traffic. A group of historic preservationists and the general public vehemently opposed the paving efforts. Finally public sentiment won out, and all future paving efforts were suspended. The Apache Trail is paved from Apache Junction to mile marker 220, remains an unpaved surface from marker 220 to 240.5, and is paved the remaining 1.5 miles to the junction of State Route 188.

The historic Apache Trail has been improved in many ways, but the spectacular scenery remains unspoiled over the last century. Though the road is not as rugged as it once was, a trip along the Apache Trail is no Sunday drive in the park. The road twists and turns, climbs several hills along narrow passages, and traverses through winding canyons, providing an experience you will always remember.

The Apache Trail is still marketed as a tourist destination and touted as a must-see destination in the American West. I hope you will enjoy your trip along the Old Apache Trail!

One

BIRTH OF ROOSEVELT DAM AND THE APACHE TRAIL

In the early days of the Arizona Territory, as pioneers began to settle the fertile valleys of the Salt River near present-day Phoenix, unpredictable water supply was a common phenomenon. In an attempt to compensate for the shortage, they followed the innovative techniques of ancient native farmers and built a series of irrigation canals to deliver river water to their fields. However, periods of drought caused the crops to dry up and wither away, while times of flood often resulted in destruction of their crops, farms, and communities. Throughout the arid West, flood control, water storage, and large-scale irrigation measures were deemed a necessity for survival. One of the first federal projects authorized under the 1902 National Reclamation Act was the Theodore Roosevelt Dam project in Arizona. Its completion would ensure a reliable source of water and power for the Phoenix metropolitan area. The site chosen for construction of the dam was called "The Crossing" by early Arizona pioneers. It was the place in the Salt River where it could be forded in periods of low flow and was near the confluence of Tonto Creek. The location was ideal for a dam since the canyon narrowed significantly at this spot. Originally proposed as the Tonto Basin Dam, it was renamed Roosevelt Dam, and even later Theodore Roosevelt Dam, after Pres. Theodore Roosevelt, in honor of his approval and support of this project. Built between 1903 and 1911, the cyclopean-masonry gravity arch dam was the highest in the world at the time and was among the last of the stone masonry dams built. On March 18, 1911, former president Theodore Roosevelt dedicated the dam named in his honor. In order to expedite the transport of supplies and materials to the massive project site, a new road was required. Although a trail existed from Roosevelt to Globe, an additional transportation link to Mesa would greatly improve the supply of materials to the site and reduce costs. The Mesa-Roosevelt Road was eventually built, originally without any documented engineering design plans and with rudimentary equipment. Surveys for the road were conducted between 1902 and 1903, and construction started in September 1903. Work was suspended shortly thereafter due to lack of funding. Bonds were issued by Phoenix, Mesa, and Tempe and work resumed in January 1904.

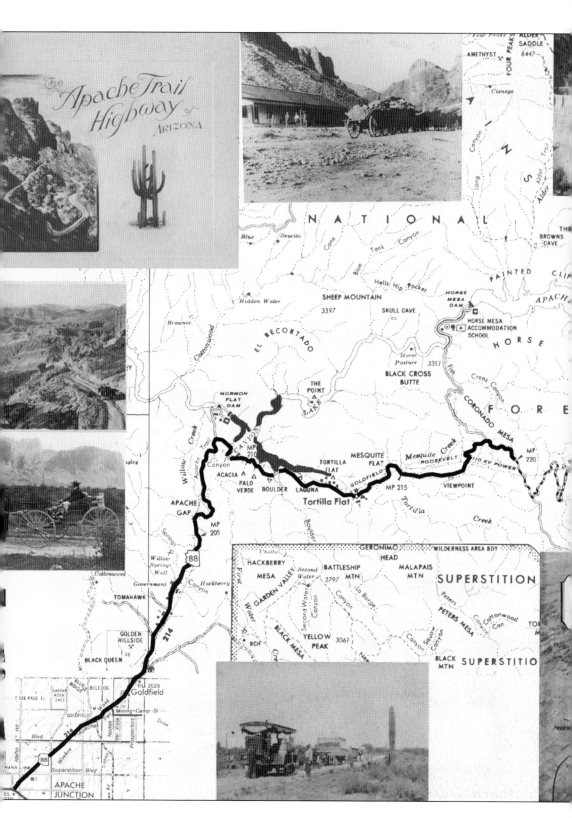

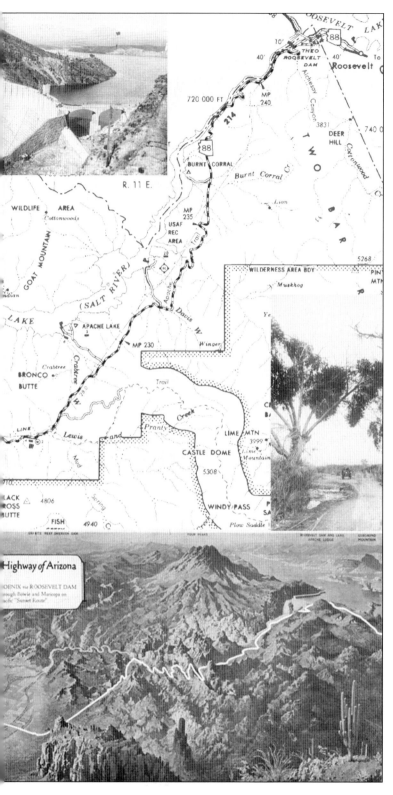

This Apache Trail map with photographs illustrates the diverse nature of the road. The map shows the current milepost locations at five-mile intervals so locations along the route can be referenced. The photograph at lower left shows the desert area with fantastic views of the Superstition Mountains, and the bottom left also shows the flat desert area. The photographs at left show the transition of terrain from low desert to mountainous terrain. At upper left, the cover of a promotional publication sports a photograph of Fish Creek Hill. The top center photograph is the Fish Creek Lodge; unfortunately, it does not exist today. The top right photograph is Theodore Roosevelt Dam in the 1920s. At bottom right is a Southern Pacific Railroad "Sunset Route" automobile road tour promotional brochure aerial map. The right middle photograph is the road to Globe near Livingston around 1904. (Map courtesy ADOT; photographs courtesy SMHS, Bureau of Reclamation, Walter J. Lubken Collection.)

13

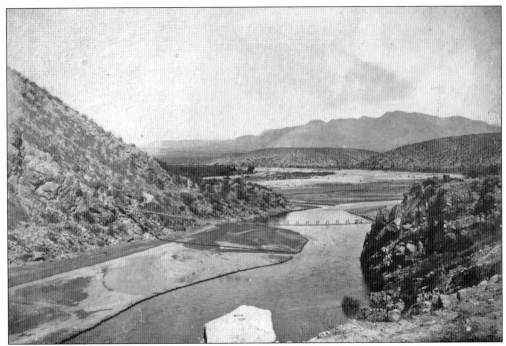

"The Crossing," the name of the site chosen to build the great Roosevelt Dam, is situated near the confluence of the Salt River and Tonto Creek. Note the suspension footbridge in the center of the photograph. This was the only reliable transportation link between the camps on the north (left) to the town of Roosevelt. (Courtesy GCHSM.)

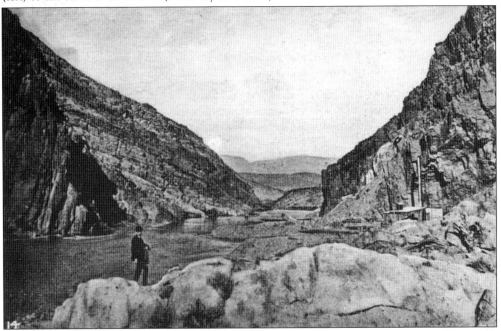

The narrow gorge, located below the confluence of rivers, provided an ideal location for Roosevelt Dam. The site was discovered in 1889 by Maricopa County surveyor William Breckenridge during a reconnaissance trip. (Courtesy GCHSM.)

Construction work is in progress at the Roosevelt Dam site just after the project began. Note the temporary suspension bridge in the middle of the photograph, used to transport materials and workers across the Salt River. (Courtesy GCHSM.)

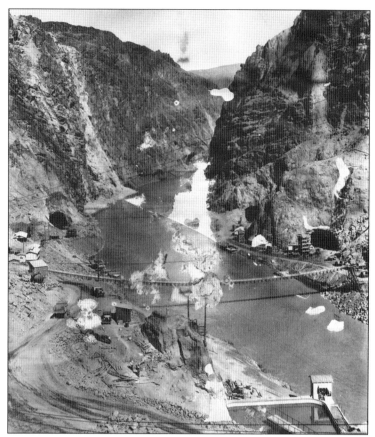

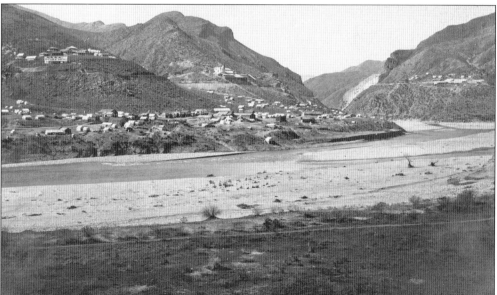

The Salt River flows serenely next to the town of Roosevelt. The town awaits its fate, as it will disappear forever under the waters of Lake Roosevelt when the dam is complete. On the upper right one can see the camps on the other side of the river. (Courtesy of SMHS.)

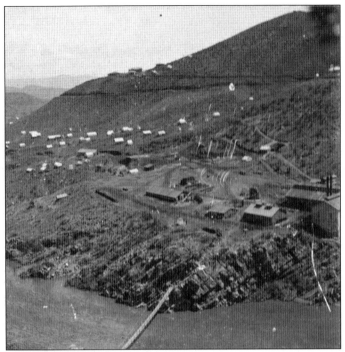

The town of Roosevelt, in the background, relied on the old suspension bridge, shown at the bottom of the photograph, to provide a vital transportation link. Schoolchildren used this bridge to travel to and from their classes. The Reclamation map below shows the location of the town of Roosevelt, the suspension footbridge, the low road to Globe, the Highline Road to Globe, and other pertinent features. (Left, courtesy SMHS, Frazier Collection; below, map redrawn based on original published by Chester Smith, Engineering News [60:266] and inset courtesy SMHS.)

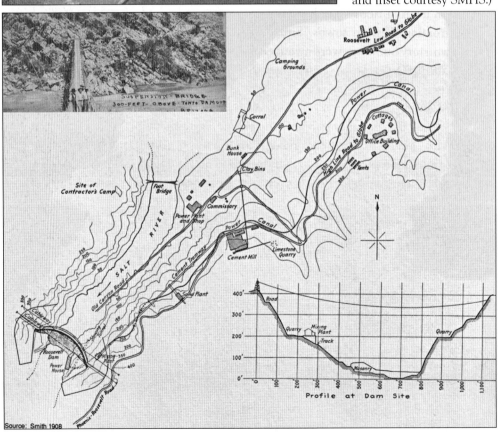

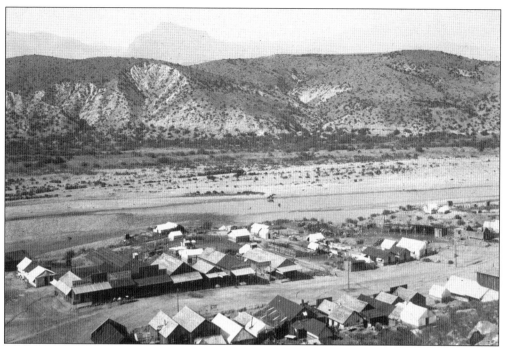

The town of Roosevelt waits to relocate to higher ground around 1907. Note the lack of heavy traffic along the main street of Roosevelt. (Courtesy Bureau of Reclamation, Walter J. Lubken Collection.)

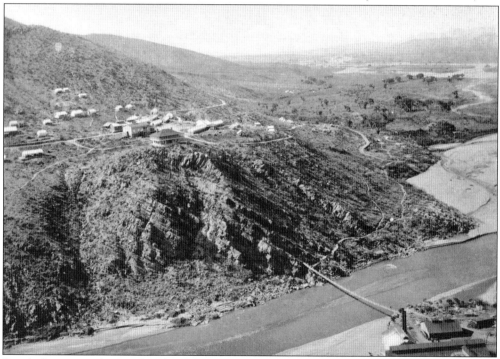

People living on the north side of the Salt River, where the contractors' camp was located, depended on the suspension bridge to reach the town of Roosevelt during the early 1900s. (Courtesy SMHS.)

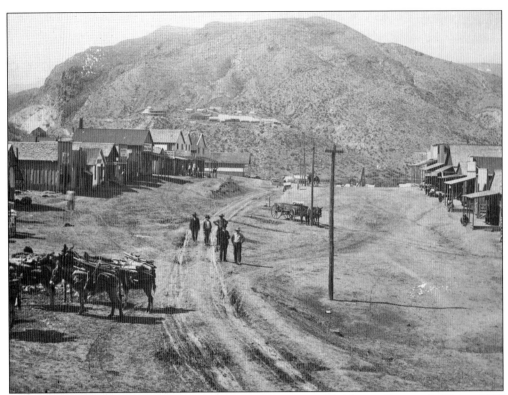

The old Globe-Roosevelt Highline Road was the main street of old town Roosevelt. The *c.* 1905 photograph below is taken from a similar vantage point showing how narrow the streets were in those days. Fortunately they left plenty of room to widen the road in the future. The town leaders did not have to worry about that dilemma as the town relocated before there was a need to widen the street. (Both courtesy SMHS.)

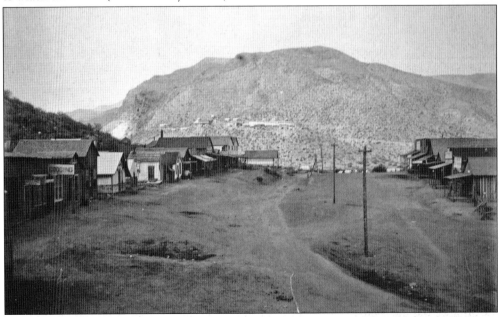

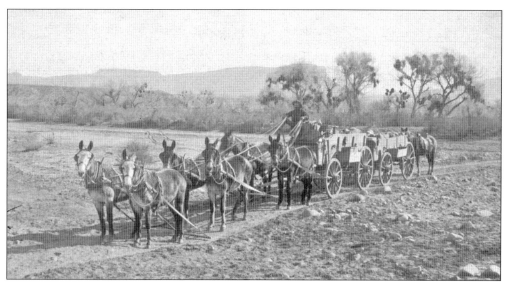

Early freighters transported supplies to the dam site from Globe along the old Highline Road. The original Highline Road was so rough and primitive in places, wagons sometimes had trouble making the journey, so extra horses and mules were often used to complete the trip. Work had just begun on the Apache Trail around 1904. (Courtesy Bureau of Reclamation, Walter J. Lubken Collection.)

The Highline Road connected the dam construction site to the town of Roosevelt and was originally the only access. A couple of workers take time to pose for a picture. Just past the cement mill in the distance was the approximate beginning point of the Apache Trail. (Courtesy SMHS.)

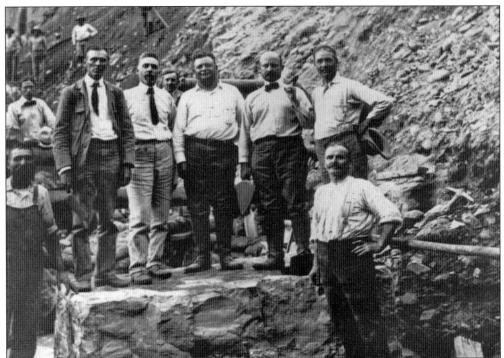

Leaders, pioneers, and engineers of Roosevelt Dam and the Apache Trail are present for the setting of the first stone in 1906. From left to right are Dan Carr; Chester Smith, Reclamation construction engineer; J. M. O'Rourke, contractor; ? Steinmetz, contractor; Louis C. Hill, Reclamation engineer; John Urquehart, inspector; and an unidentified man. (Courtesy GCHSM.)

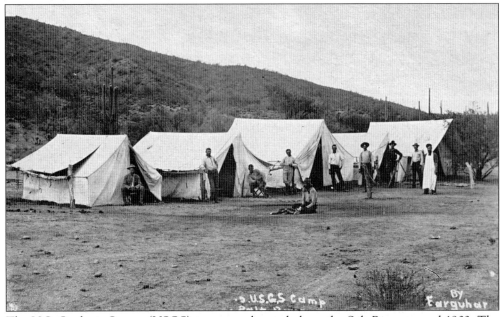

The U.S. Geologic Survey (USGS) camp was located along the Salt River around 1903. The surveyors lived in tents so they could relocate along the route as needed to complete their work. (Courtesy SMHS.)

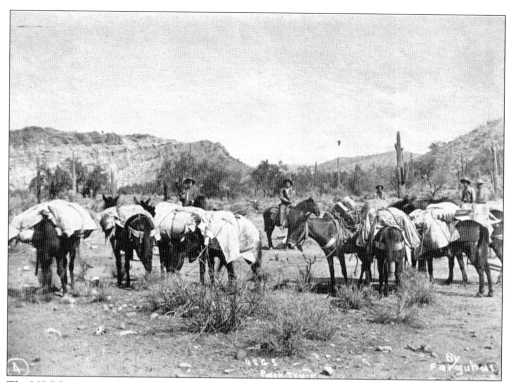

The USGS surveyors have their equipment and supplies loaded up for the day's work. Their heavy equipment was carried by mules. Below, the surveyors are setting the alignment of the road along a steep hillside. Look closely and the transit can be seen in the center right of the photograph. (Both courtesy SMHS.)

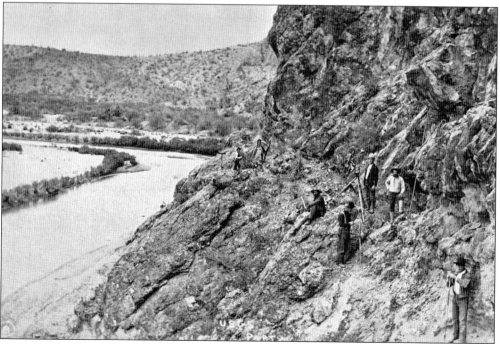

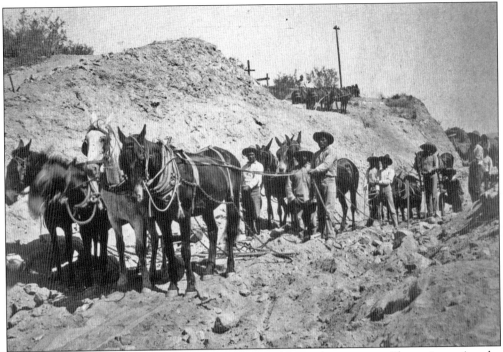

Construction in 1906 used primarily hand labor and limited equipment. Shown is an Apache work crew excavating the new cut off the canal near Roosevelt. (Courtesy Bureau of Reclamation, Walter J. Lubken Collection.)

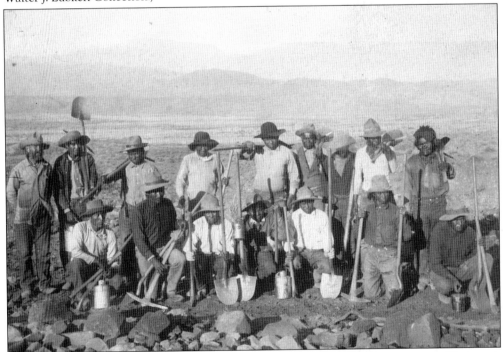

Native American laborers (shown around 1906) played a vital role in the construction of Roosevelt Dam and the Apache Trail. (Courtesy Bureau of Reclamation, Walter J. Lubken Collection.)

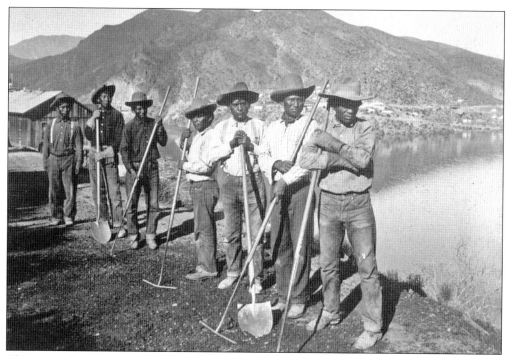
This crew of workers completed surface work along the Highline Road and likely the Apache Trail. (Courtesy Bureau of Reclamation, Walter J. Lubken Collection.)

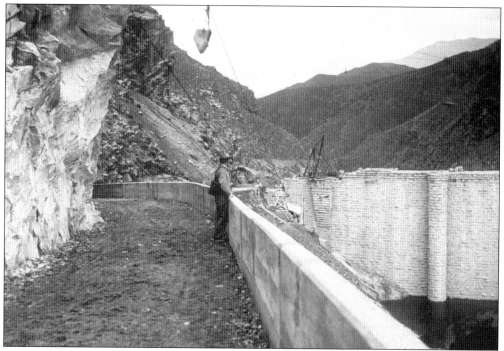
This new road, pictured around 1910, will cross on top of the dam and connect to the Tonto Basin area. Though not part of the Apache Trail, this road provided a transportation link to Tonto Basin. (Courtesy Bureau of Reclamation, Walter J. Lubken Collection.)

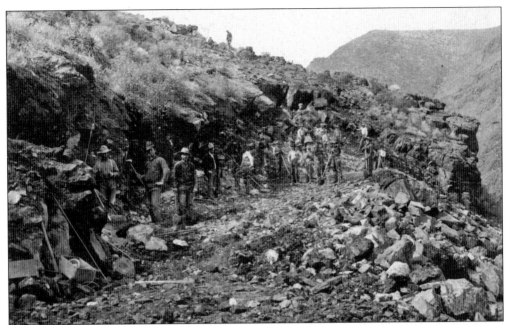

Hand excavation work was a common sight on the Apache Trail near Roosevelt Dam, here in about 1904. Wages for this backbreaking work ranged from $1.50 to $2 per day. (Courtesy SMHS.)

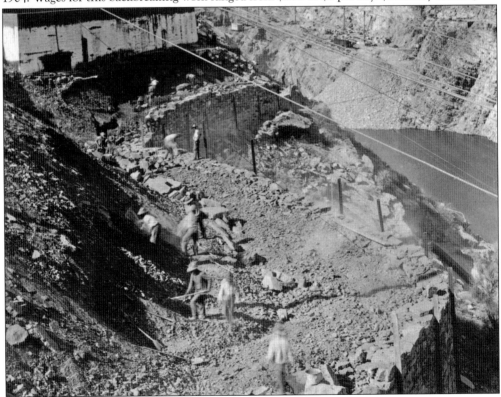

A work crew completes hand finish work on the roadway slopes around 1904. This segment of road is just below the present Forest Service scenic vista overlooking Roosevelt Dam. (Courtesy SMHS.)

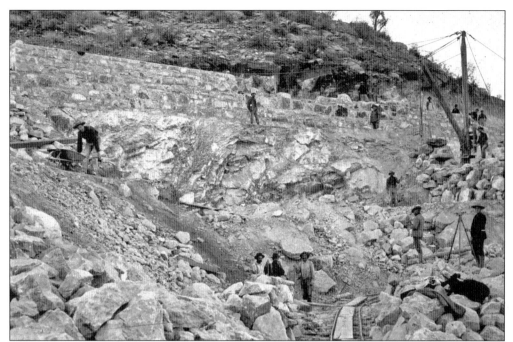

Reclamation workers construct rock retaining walls near Roosevelt Dam on the Apache Trail in about 1904. The retaining walls along the Apache Trail are both dry laid and cement mortar type. (Courtesy Bureau of Reclamation, Walter J. Lubken Collection.)

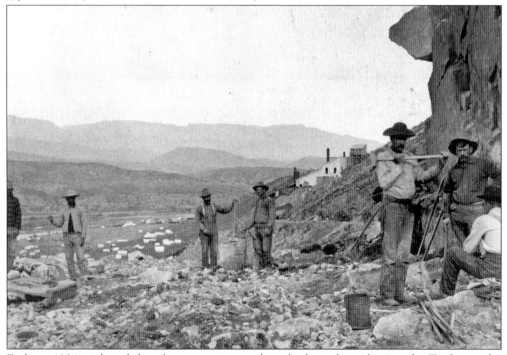

Early, c. 1904, pick-and-shovel construction work took place along the Apache Trail near the dam site. Mile marker zero, the beginning of the original Apache Trail, is near this location. (Courtesy SRP.)

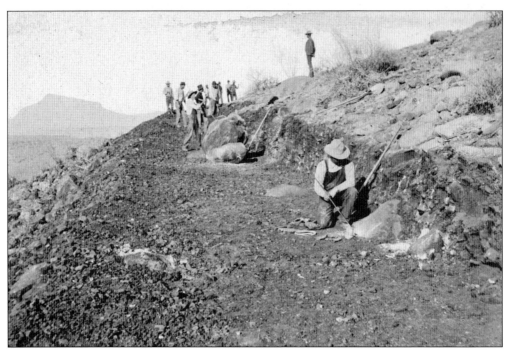
Laborers work along the Highline Road to Globe around 1904, performing hand excavation work. (Courtesy Bureau of Reclamation, Walter J. Lubken Collection.)

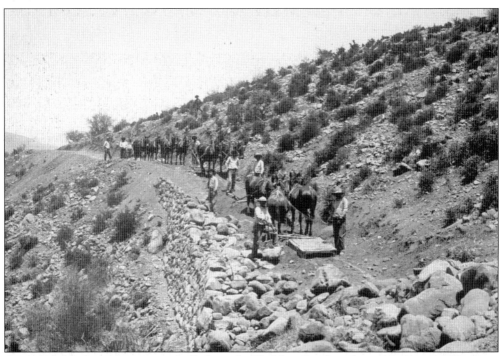
Crews hand laid a rock retaining wall along the Highline Road in this c. 1904 image. This type of construction method was used for the majority of the walls along the Apache Trail. (Courtesy Bureau of Reclamation, Walter J. Lubken Collection.)

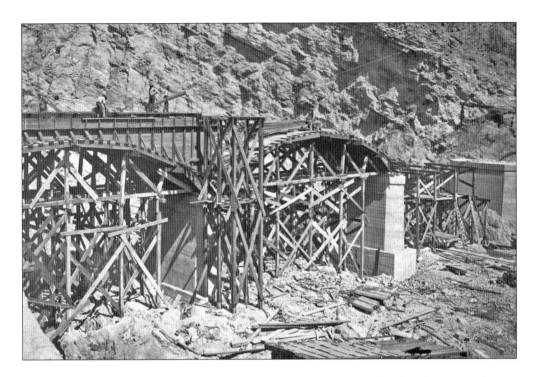

The approach bridge was under construction on the north side of the dam here around 1910. Although not part of the Apache Trail, this road provided a vital transportation link to the communities and contractor camp located across the river. (Both courtesy Bureau of Reclamation, Walter J. Lubken Collection.)

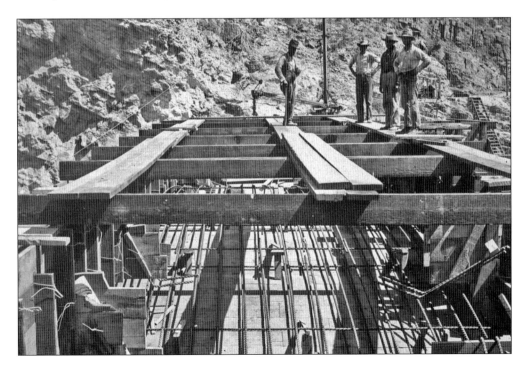

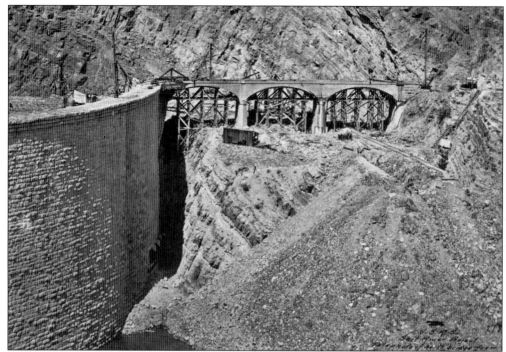

The approach bridge on the north side of the river neared completion around 1910. Note that there is very little water against the dam. (Courtesy Bureau of Reclamation, Walter J. Lubken Collection.)

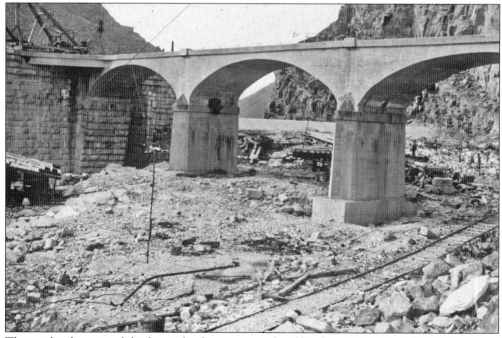

The south side approach bridge to the dam was completed by about 1910. These bridge structures were removed when the dam reconstruction work was completed. (Courtesy Bureau of Reclamation, Walter J. Lubken Collection.)

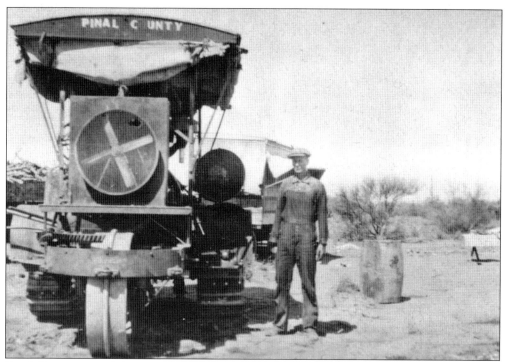

Pinal County provided some modern equipment to perform work on the Apache Trail in the early 1900s. (Courtesy of SMHS.)

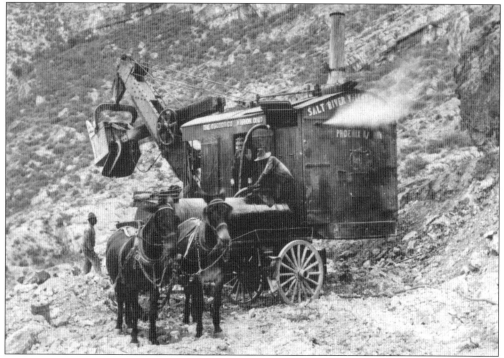

A modern steam shovel was used in the later stages of construction. This machine was owned by the Salt River Valley Water Users Association. (Courtesy of SMHS.)

The early power line towers are constructed along the Apache Trail. These structures were windmill towers purchased from the U.S. Wind Engine and Pump Company at discounted prices. (Both courtesy Bureau of Reclamation.)

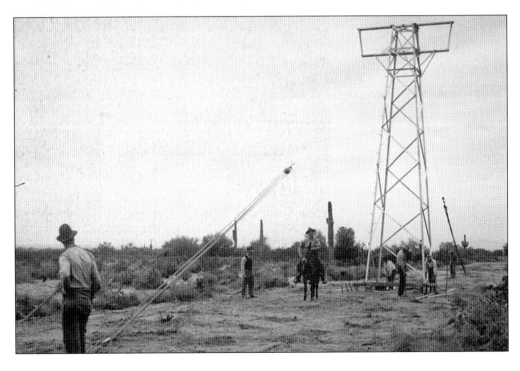

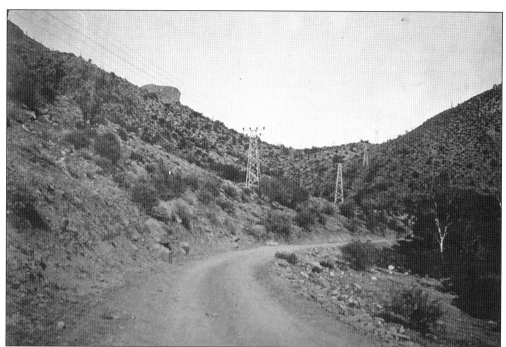

This image of the Apache Trail (above) shows the completed power line towers. (Courtesy Bureau of Reclamation.)

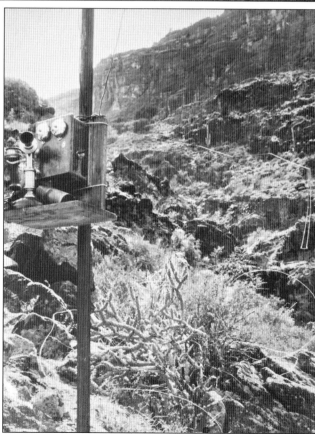

Perhaps this telephone located alongside the Apache Trail is an early call box. (Courtesy SMHS.)

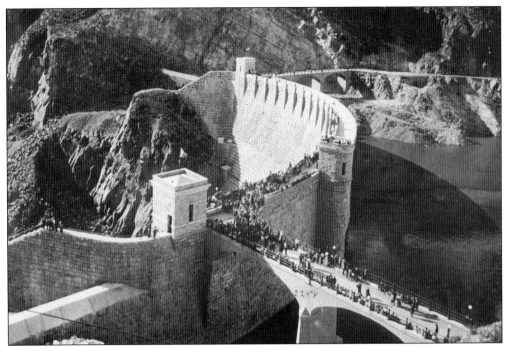
The Roosevelt Dam dedication ceremony took place on March 18, 1911. This photographer must have climbed a hillside for this shot. (Courtesy SMHS, Fred Hoar Collection.)

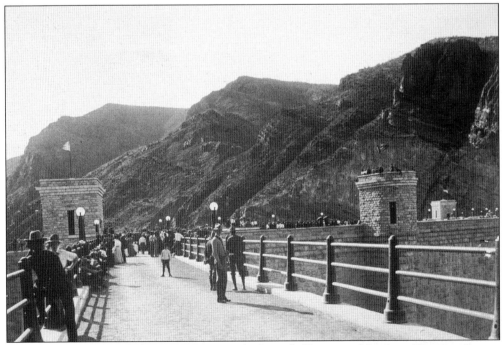
The public enjoyed the dedication ceremony, which was held on top of the dam. (Courtesy Bureau of Reclamation, Walter J. Lubken Collection.)

The dedication ceremony was a family event. These kids appear to be enjoying themselves. (Courtesy GCHSM.)

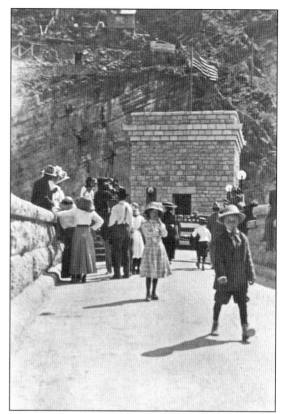

Former president Theodore Roosevelt leads a group of dignitaries to the dedication ceremonies on top of the dam on March 18, 1911. The *Arizona Democrat* used a unique method to transmit the story of the dedication back to Phoenix—carrier pigeons. (Courtesy SMHS, Fred Hoar Collection.)

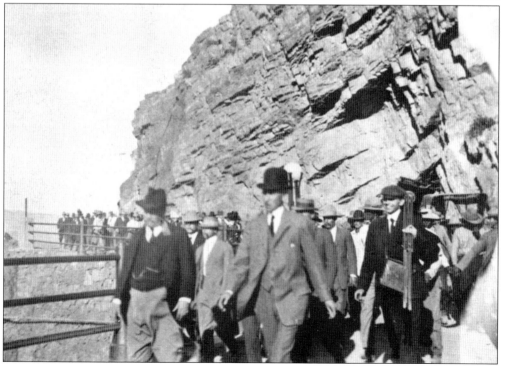

The old Highline Road winds its way along the relocated portions of the old town of Roosevelt around 1910. (Courtesy Bureau of Reclamation, Walter J. Lubken Collection.)

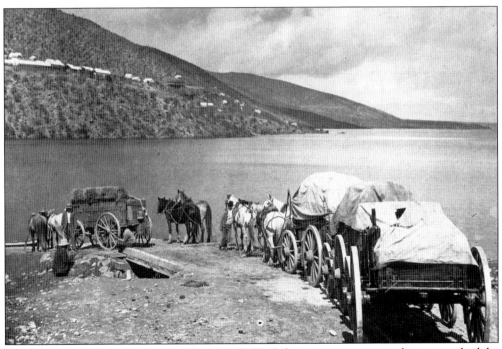

Freighters used a U.S. Reclamation Services (USRS) ferry to transport supplies across the lake near the dam around 1910, prior to completion of the road on top of the dam. (Courtesy Bureau of Reclamation, Walter J. Lubken Collection.)

Two
EARLY DAYS OF THE APACHE TRAIL

Surveys of the Mesa-Roosevelt Road were conducted in 1903. Construction began immediately thereafter, and work continued until it was completed in 1905. During construction of the dam, use of the road was closely monitored by Reclamation. During a short period of time, multiple public transportation services were allowed and the road was shared by both stagecoach and automobile. In 1905, the stagecoach service took 12 hours to complete the one-way trip with several stops to change teams of horses, while the 14-passenger touring automobiles made the trip in 90 minutes less time. Eventually the automobile completely replaced horse-drawn vehicles as the preferred mode of travel. Freight hauling continued for several years; however, the heavy loads pulverized the soil on the roadbed, requiring the need for continuous grading on the lower desert sections of the road near Government Well. Gravel and paved surfaces on engineered base courses were soon constructed to improve durability. Soon after completion of the dam, public travel increased and so did the demand for road improvements. Milepost markers were installed in 1906 to give motorists information regarding distance and location. The original mile markers were constructed of concrete with embossed numbers to indicate the remaining distance to either Mesa or Roosevelt. There were different numbers on each side of the post depending on direction of travel. Later and current mile markers show the same number on both sides. The numbers depicted a distance from a specific reference, or starting point. Interestingly, today there is no mile marker 217 on the Apache Trail; this is due to various realignments that occurred in the vicinity of Canyon Lake. According to the *Arizona Republican*, Louis Hill made the first documented private automobile trip in 1907 from Phoenix to Roosevelt along the road. The trip was made in an astonishing six hours, including a lunch stop at Fish Creek Station.

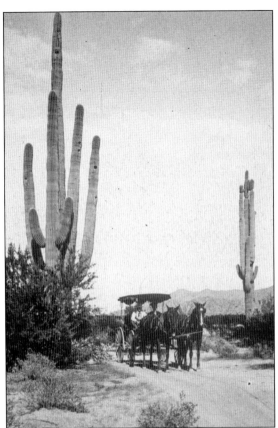

Early travelers are out for a c. 1906 Sunday drive along a lower portion of the Apache Trail. (Courtesy Bureau of Reclamation, Walter J. Lubken Collection.)

An early horse carriage travels along the trail. Note the milepost marker at the left side of the picture. These were installed in 1906 to indicate the distances to Mesa in one direction and to Roosevelt in the other. In this photograph, the traveler is 49 miles away from Roosevelt. The original mile markers started with zero near the dam and ended with 60 in Mesa. Of course, they had numbers on both sides, so one can decide which end was really the starting point. (Courtesy Bureau of Reclamation, Walter J. Lubken Collection.)

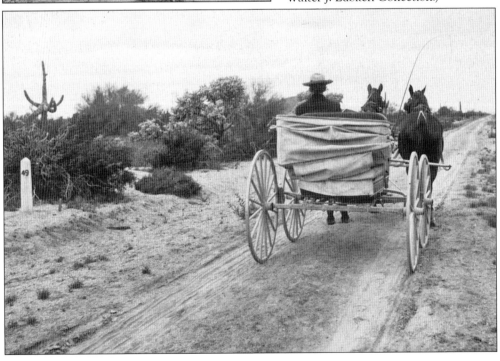

A two-horsepower vehicle travels along the Apache Trail somewhere between Desert Wells and Government Well in about 1907. (Courtesy Bureau of Reclamation, Walter J. Lubken Collection.)

This two-horsepower vehicle travels past an old mine near Goldfield, Arizona. (Courtesy Bureau of Reclamation, Walter J. Lubken Collection.)

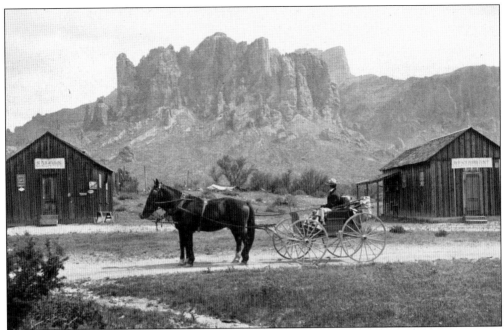

Along the Apache Trail near Goldfield, a stage stop lies here abandoned. (Courtesy Bureau of Reclamation, Walter J. Lubken Collection.)

This adventurous traveler stops to take a c. 1907 photograph of the Apache Trail with Superstition Mountain in the background. He surely appreciated the spectacular views from mile marker 17. This could be Walter Lubken's buggy. From 1903 to 1917, Walter J. Lubken was an official photographer for U.S. Reclamation. He took thousands of photographs documenting irrigation projects in the American West. (Courtesy Bureau of Reclamation, Walter J. Lubken Collection.)

Early travelers enjoyed the views along the Apache Trail. This photograph near Goldfield shows the majestic Superstition Mountains in the background. (Courtesy Bureau of Reclamation, Walter J. Lubken Collection.)

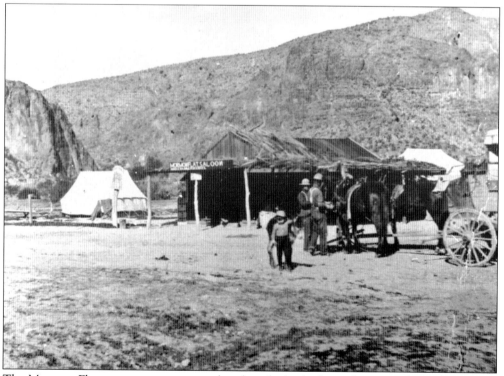

The Mormon Flat stage stop was a popular place for both thirsty horses and travelers. In the center is the Mormon Flat Saloon, where dusty travelers used to stop and wet their whistles. (Courtesy SMHS.)

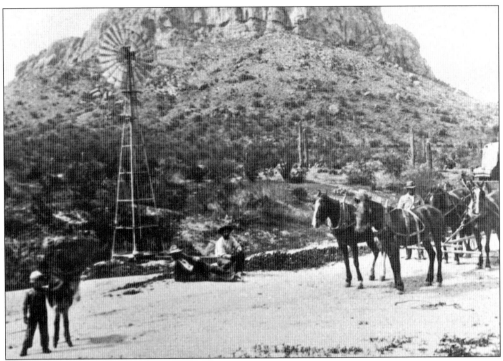
A team of freighters en route to Roosevelt with vital supplies stops for a water and rest break along the Apache Trail near Government Well around 1906. (Courtesy SMHS.)

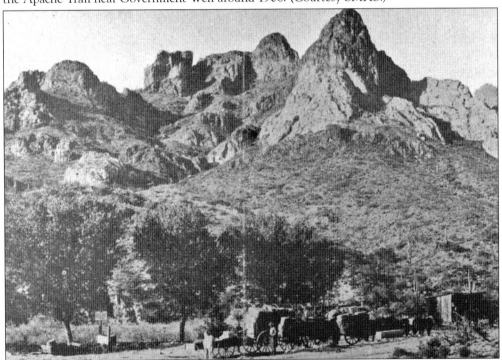
Another freighter stops at Government Well for water. Several water stops were located along the Apache Trail, so horses could complete the difficult journey. (Courtesy SMHS.)

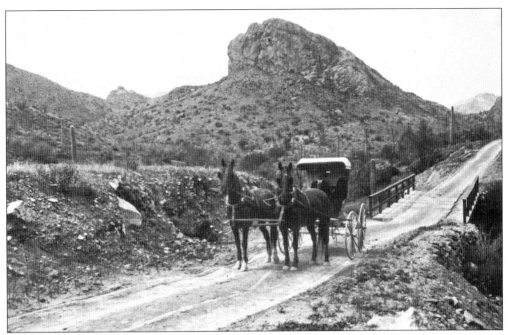

A horse-drawn carriage travels along the Apache Trail in 1907. The bridge they have just crossed was located near Government Well station and has long since been replaced by culverts. (Courtesy Bureau of Reclamation, Walter J. Lubken Collection.)

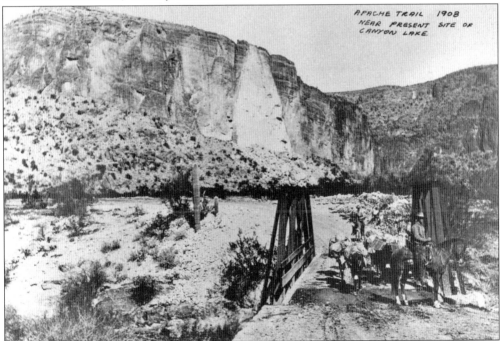

This 1908 photograph shows an old timber bridge near Canyon Lake. This segment of the road is no longer in service. When ownership of the Apache Trail was transferred to the state, the Arizona Highway Department (AHD) replaced all timber bridges, saying they were "of questionable strength and durability." (Courtesy SRP.)

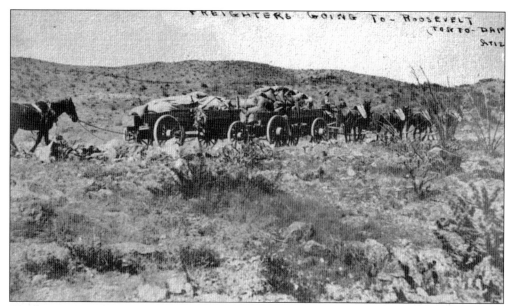

Freighters continuously delivered supplies to the dam site along the old Apache Trail. Use was so great at one point that travelers described the road as "a pulverized powdery surface" along the lower desert portions. (Courtesy SMHS, SRP, William J. Morrel Collection.)

This adventurous traveler fords Boulder Creek, one of the many washes that cross the Apache Trail. Initially there were few culverts and bridges built; however, as use increased, the road was upgraded and these features were constructed. (Courtesy Bureau of Reclamation, Walter J. Lubken Collection.)

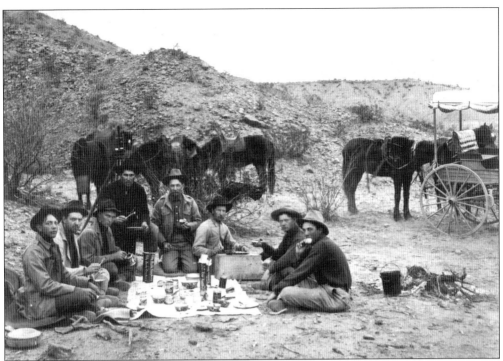
A group of travelers stops for lunch along the Apache Trail near Apache Lake. There were no modern conveniences along the road in those days, but this group does not seem to mind. (Courtesy SMHS.)

This image is of the Apache Trail near Mormon Flats looking west from the east end, just before entering Tortilla Flat. (Courtesy Bureau of Reclamation, Walter J. Lubken Collection.)

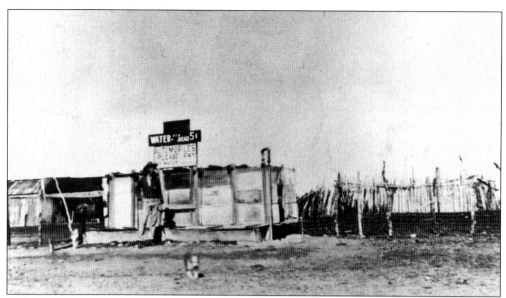

The Weekes Station, along the lower portion of the Apache Trail, in 1905 featured water for sale at a staggering 5¢ per head (each horse). Travelers also paid for water for their automobiles. (Courtesy SMHS.)

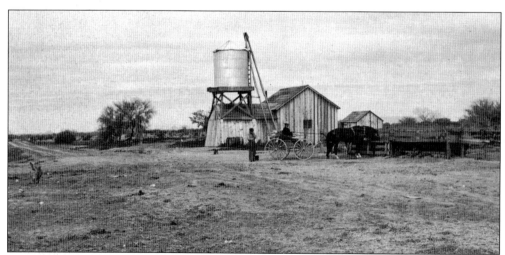

The stage stop at Desert Wells was the first for travelers after leaving Mesa. This c. 1907 station was one of several located along the route. (Courtesy Bureau of Reclamation, Walter J. Lubken Collection.)

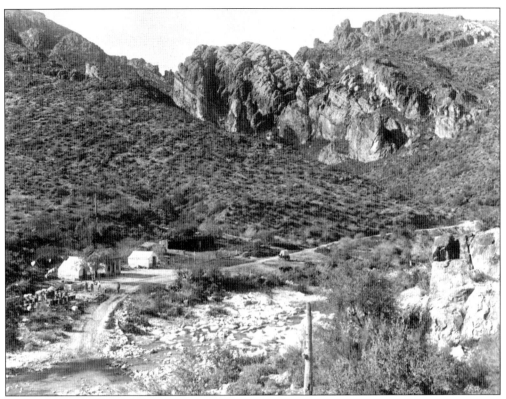

Farther along the Apache Trail, a stage stop was established called Tortilla Flat (above). This historic place exists today. The buildings have all been replaced, but it is well worth visiting. (Courtesy Bureau of Reclamation, Walter J. Lubken Collection.)

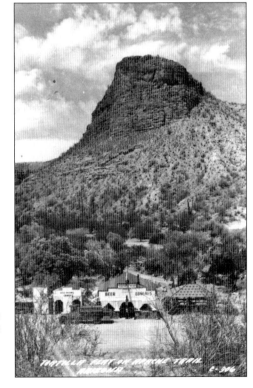

Tortilla Flat has an array of beautiful scenic views. Originally built as a stage stop in 1904, Tortilla Flat evolved into a settlement. This is a popular place for tourists to stop and rest before they venture on to the difficult section of the trail. It has been rebuilt several times from the result of flood and fire. (Courtesy SMHS.)

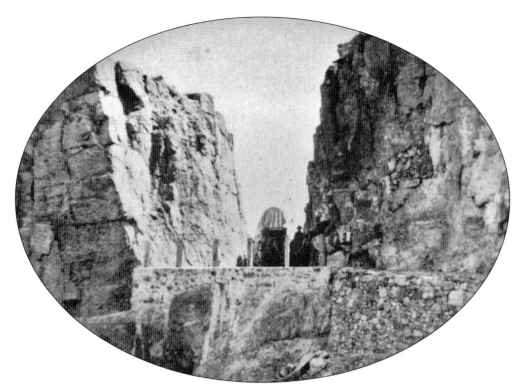

A stagecoach travels through one of the narrow sections of the Apache Trail area around 1900. Note the early version of guard posts and the intricate retaining walls. (Courtesy SMHS.)

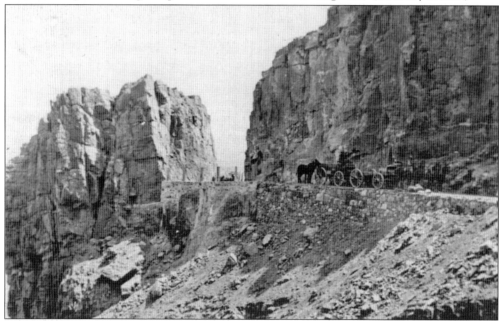

Along the road, there are several areas with room for only one vehicle at a time, as can be seen. Freighters used caution travelling through these areas to avoid losing their load over the cliffs. (Courtesy SMHS.)

This photograph shows the same location as the two previous ones but from the opposite direction. Does it look any wider from this vantage point? (Courtesy SRP.)

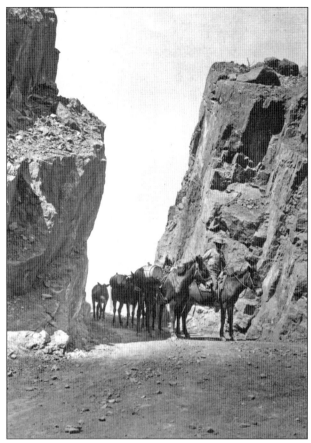

The initial descent into Fish Creek Canyon is along a narrow one-vehicle-wide pathway (below). Here a traveler stops to enjoy the view or maybe to see if someone is approaching from the other direction. (Courtesy SMHS.)

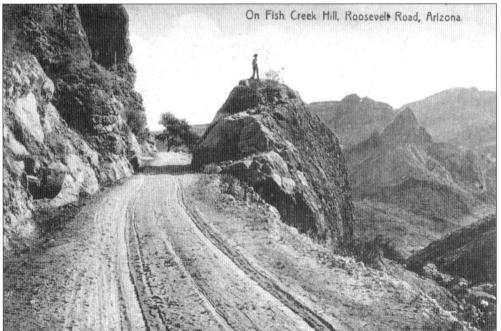

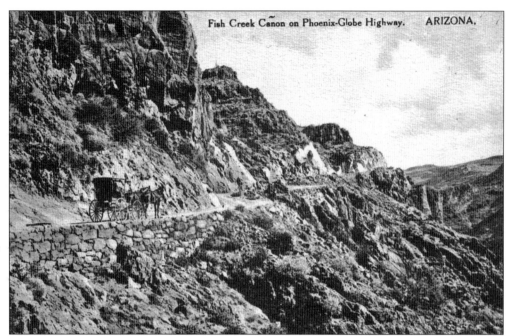
The ascent and descent of Fish Creek Hill was not only challenging, it was also was time consuming, taking horses nearly 45 minutes to make the journey. (Courtesy SMHS.)

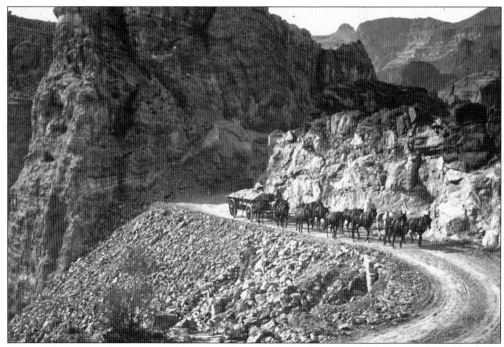
This loaded freight wagon ascending out of Fish Creek Canyon could take over an hour to make the climb. (Courtesy Bureau of Reclamation, Walter J. Lubken Collection.)

These brave souls appear to be unconcerned with the narrow road width and nearly vertical drop-offs. (Courtesy SRP.)

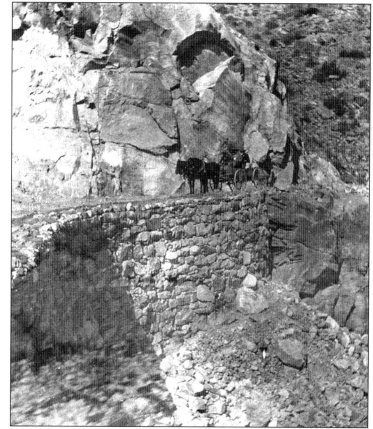

The road traverses extreme terrain in the vicinity of Fish Creek, seen here around 1905. Note the drop-off at the far right of this photograph. (Courtesy Bureau of Reclamation, Walter J. Lubken Collection.)

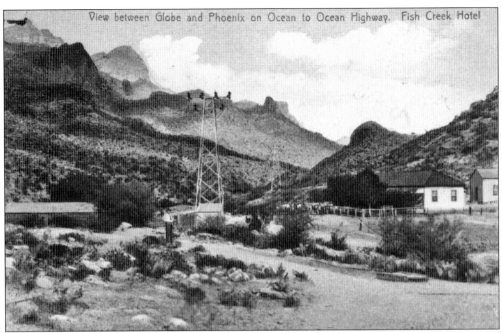

Located about one mile east of the Fish Creek Bridge was the Fish Creek Lodge. This station served as a stage stop, automobile stop, restaurant, and motel. (Courtesy SMHS.)

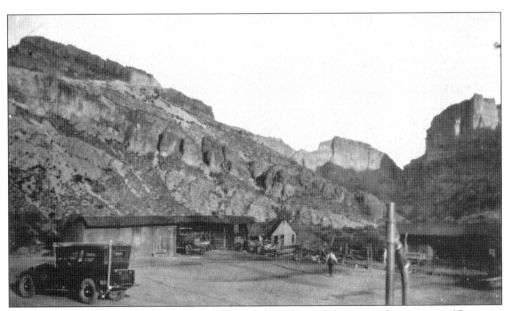

This view of the Fish Creek Station shows the stable and corrals being used as a garage. (Courtesy Stan Gibson.)

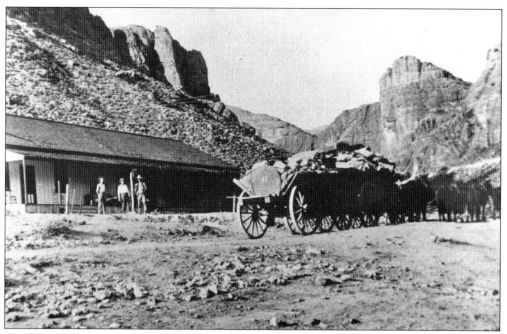

Freighters stopped at the Fish Creek Lodge for rest, food, and water for their horses in preparation for the long ascent up the steep grade of Fish Creek Hill. (SMHS.)

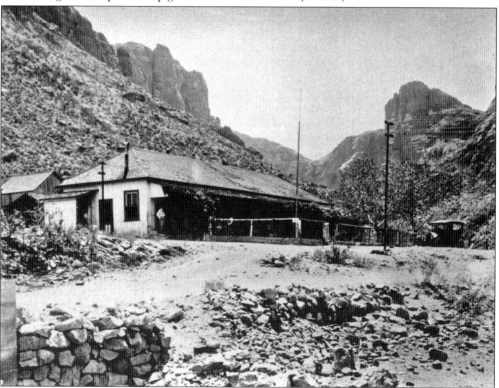

Those traveling down the long grade also found the Fish Creek Lodge a welcome sight for rest and a good meal. (Courtesy SMHS.)

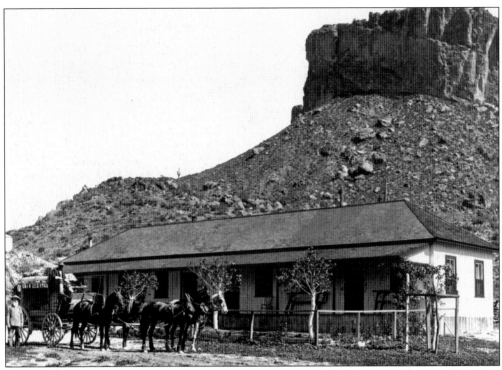

The stagecoach made regular stops at the Fish Creek Lodge for a rest in the early 1900s. The Phoenix-to-Globe motor stage made frequent stops with their tourists in the late 1910s. Note that these photographs were taken from almost identical locations and the trees grew a little bit during those years. (Above, courtesy SMHS; below, courtesy Stan Gibson.)

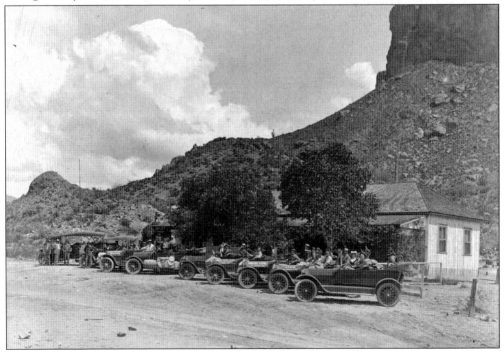

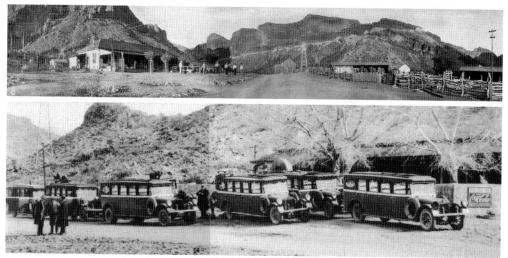

Two panoramic views show Fish Creek Lodge. Above, the top image shows the lodge on the left, corrals on the right, and Fish Creek Hill grade in the middle background. The bottom photograph shows a caravan of touring cars stopped at the lodge. (Above top, courtesy SMHS; above bottom, courtesy Jodi Akers.)

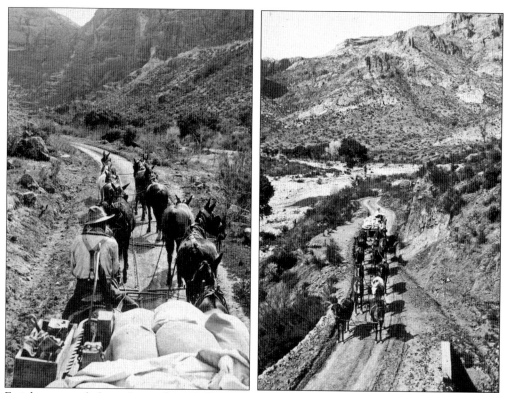

Freighters travel along the road just before entering Fish Creek Station (left) and, after leaving the bottom of Fish Creek Hill, on the Roosevelt wagon road (right). (Both courtesy Bureau of Reclamation, Walter J. Lubken Collection.)

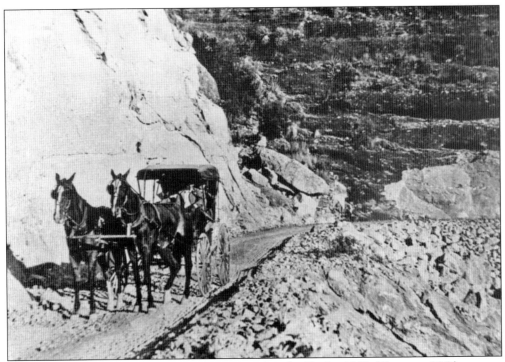

Another horse carriage travels along the narrow Apache Trail c. 1905. (Courtesy SRP.)

This horse appears to be looking for its rider. Maybe the rider is taking a rest stop or perhaps prospecting for gold. (Courtesy Bureau of Reclamation, Walter J. Lubken Collection.)

This mail stage travels along the old Roosevelt Road around 1904. The stage made regularly scheduled trips with mail and passengers until replaced by the automobile. (Courtesy SMHS.)

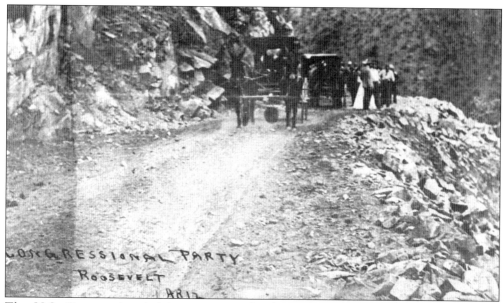
The U.S. Congressional delegation travels along the Apache Trail to observe the progress of the Roosevelt Dam and Water Users distribution system. (Courtesy SRP, William J. Morrel Collection.)

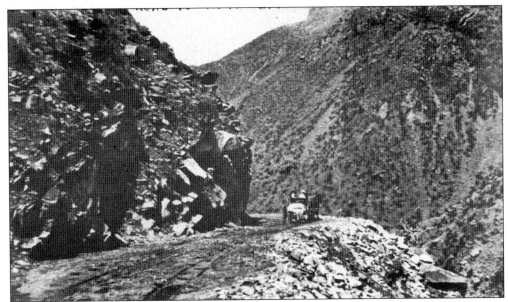

A horse carriage travels down the road toward Mesa near Roosevelt Dam in the early 1900s. (Courtesy SRP, William J. Morrel Collection.)

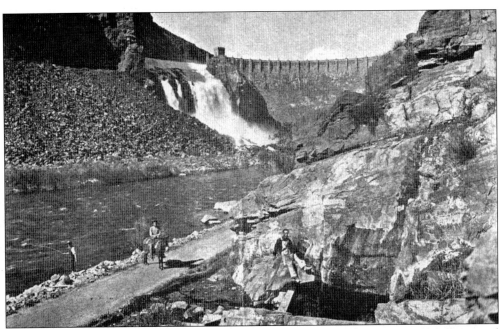

The Apache Trail served the public for recreational opportunities even before it officially opened to traffic. Even today, Apache Lake, along the Apache Trail, is a popular recreation destination for Arizonians. (Courtesy SMHS.)

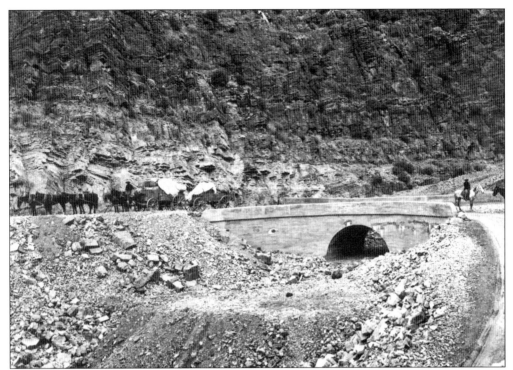
Freighters make their final climb from Alchesay Canyon toward the town of Roosevelt. (Courtesy SRP.)

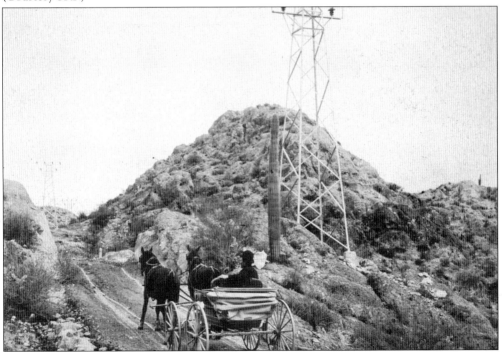
Drivers frequented the old Apache Trail for a leisurely ride in 1909. Note the narrow road and the power line tower. (Courtesy Bureau of Reclamation, Walter J. Lubken Collection.)

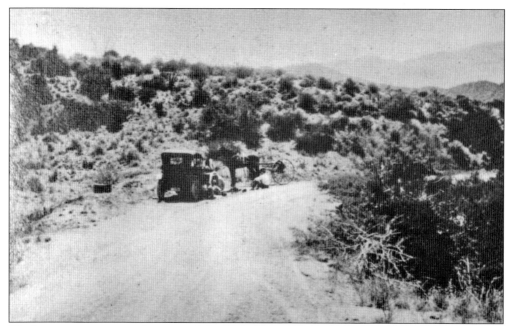

The horse carriage meets the automobile along the Apache Trail. It appears they have stopped to visit, possibly to discuss the condition of the roads they are about to pass over. (Courtesy SMHS, Helm Collection.)

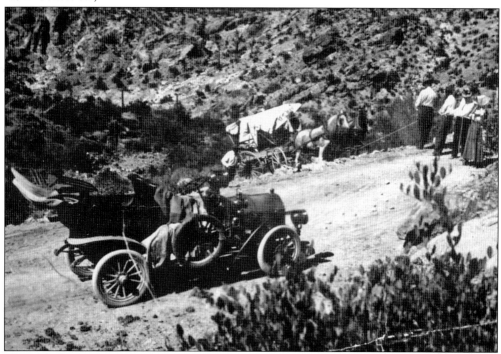

The end of an era occurred as the stagecoach was replaced by the automobile. This stagecoach accident occurred in 1910 as a curious motorist stops to assist. Horse carriages and stagecoaches were soon permanently replaced by the automobile as the preferred mode of travel. (Courtesy Bureau of Reclamation, Walter J. Lubken Collection.)

Three

PUBLIC USE AND SUNDAY DRIVES

Eventually the road became a popular destination for motorists to take Sunday drives. For a short period of time, there was even unsanctioned informal auto racing until it was abruptly halted by Reclamation with the threat of hefty fines if anyone was caught speeding. According to the *Arizona Republican* on September 2, 1909, engineer W. A. Farish set the first speed limit for the mountainous sections of the road at 15 miles per hour. Around the same time, three significant factors would nearly cause the trail to slip into obscurity forever. First was the issue of ownership of the road. Public pressure was prevalent and persistent that the road be kept open for traffic in a safe, passable condition. Second, a new modern state highway was built from Mesa-Apache Junction to the Globe-Miami area. This highway, completed in 1922 and referred to as the "Million Dollar Highway," reduced the trip by 20 miles and became the main route of travel. Third, the recently completed Horse Mesa Dam grabbed the public spotlight when it caused a temporary closure of the road. Officials negotiating a new alignment nine miles below the dam failed to reach an agreement before the dam was completed, resulting in the submersion of the road by the backwater of Apache Lake on June 24, 1927. A major uproar arose from both the general public and the Southern Pacific Railroad, which had just printed over 100,000 new brochures promoting side trips along the road. Although inconvenienced by the closure, the railroad was able to ferry passengers around the closed portion of the road by boat and continue operations. This controversy sparked intense debate regarding the management of the state's highway system. This resulted in the formation of a new State Highway Commission, with the responsibility and authority to allocate proper funding for improvements statewide and most importantly to ensure that proper planning and management of the highways occurred to prevent road closures. The new commission immediately allocated the funds, state forces completed the realignment, and the road was reopened in December 1927. Also in 1927, the Federal Highway Administration developed a national requirement for the numbering of all state highways. The Apache Trail, as one of the original state-operated roads, was designated State Route 88 and received its first road maintenance section (No. 32), managed by J. A. Cardin, according to *Arizona Highways* in March 1928.

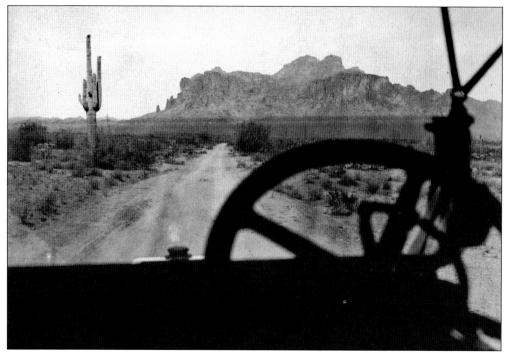

The automobile became the preferred mode of travel on the Apache Trail by the early 1910s. The steering wheel is on the right side of the vehicle as this motorist travels the narrow road with the majestic Superstition Mountains ahead. (Courtesy Bureau of Reclamation, Walter J. Lubken Collection.)

The view of the Superstition Mountains from the Apache Trail traveling toward Mesa near Goldfield, Arizona, is spectacular. (Courtesy SMHS.)

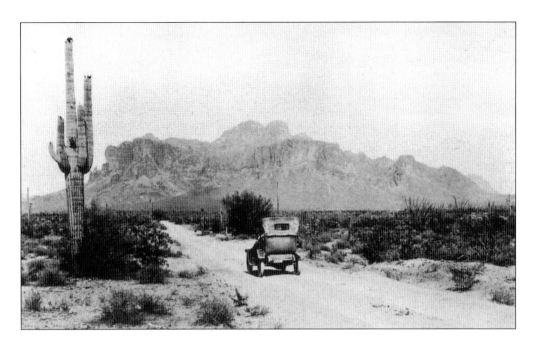

This Sunday driver starts out along the Apache Trail near Goldfield. The narrow road, the large saguaro cactus, and the fantastic views add to the enjoyment of the trip. (Both courtesy SMHS.)

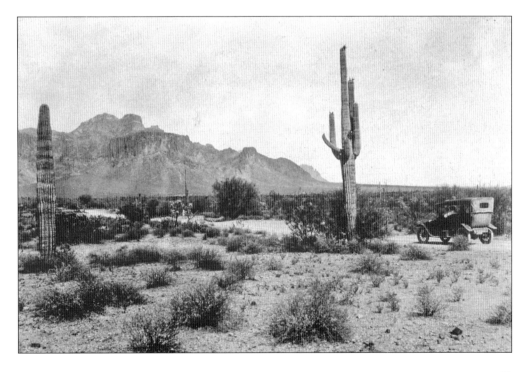

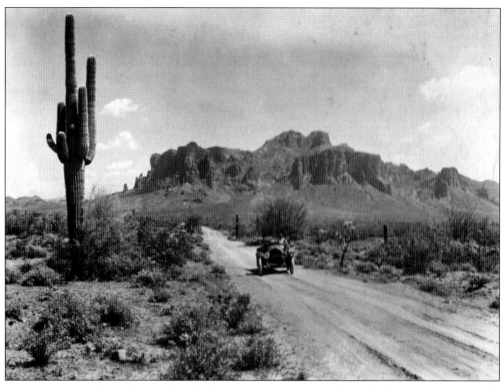

A motorist races along the Apache Trail in a desert section of the road. Racing was eventually banned by Reclamation, and hefty fines were levied on those caught speeding along the road. (Courtesy SMHS.)

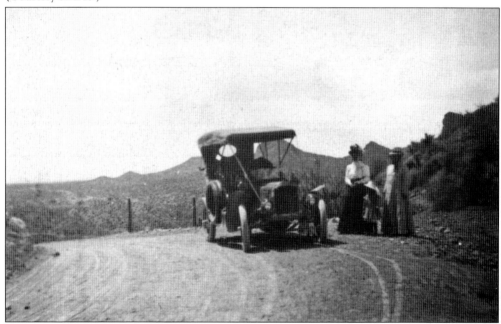

This group of Sunday drivers stopped to enjoy the views near Belamy Ranch prior to completion of the Superior Highway. (Courtesy SMHS, Fred Hoar Collection.)

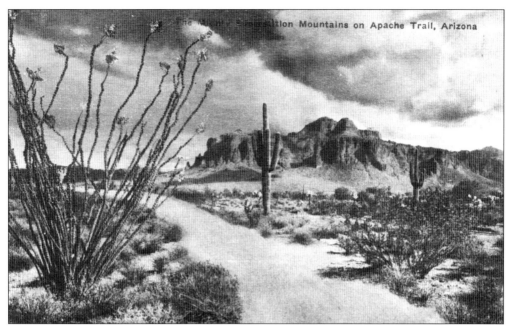

Apache Trail near Goldfield is surrounded by beautiful desert scenery in this c. 1910s photograph. The pure unspoiled beauty along the road was surely appreciated by travelers. (Courtesy SMHS.)

Weekes Ranch by the old water stop on the road to Roosevelt is where the road forked to go to either Superior or Phoenix. The road was moved around 1920 to the current location near Apache Junction. Groceries and sodas were sold to travelers who stopped. (Courtesy SMHS.)

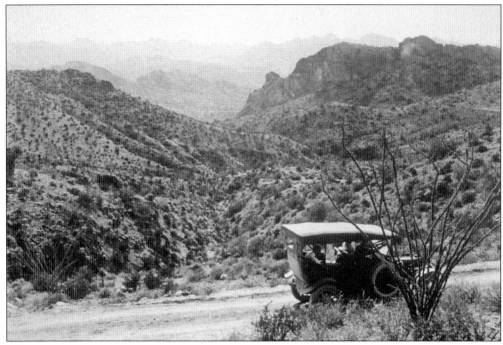

Sunday drivers were treated to spectacular scenery all along the way on the Apache Trail. This was the view in 1914 near old mile marker 25. What a fun adventure! (Courtesy Bureau of Reclamation, Walter J. Lubken Collection.)

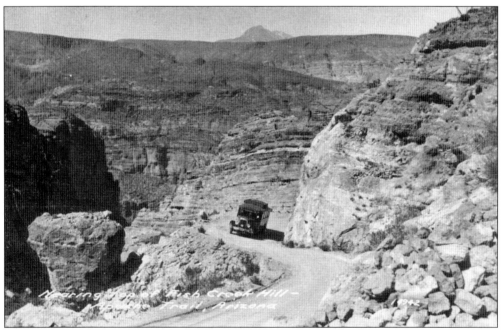

Touring companies were providing regular scheduled scenic trips along the Apache Trail by 1916. This touring car is climbing out of Fish Creek Canyon headed for Mesa or Phoenix. (Courtesy SMHS.)

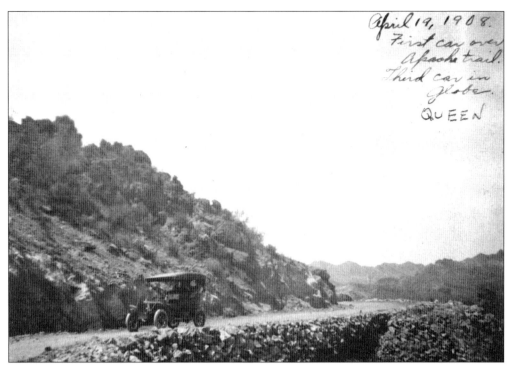

This was supposedly the first car, named Queen, to travel from Globe over the Apache Trail, on April 19, 1908. According to the *Arizona Republican* of February 13, 1907, the first documented private automobile trip was made by Louis Hill on February 8, 1907. The entire one-way trip took six hours, including stop for freighters and lunch. The trip up Fish Creek Hill Grade took only 16 minutes. The J. Holdren and Sons stage line ran an automobile from Mesa to Government Well beginning August 25, 1905. (Courtesy SMHS, Fred Hoar Collection.)

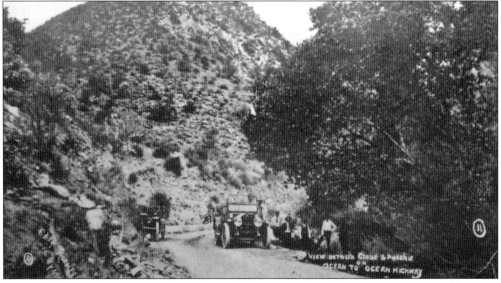

A group of travelers stops for a break to enjoy the view and to pose for a picture. In addition to being referred as the Phoenix-Roosevelt Road and Mesa-Roosevelt Road, the Apache Trail was also the Ocean to Ocean Highway. (Courtesy SMHS, Gribble Collection.)

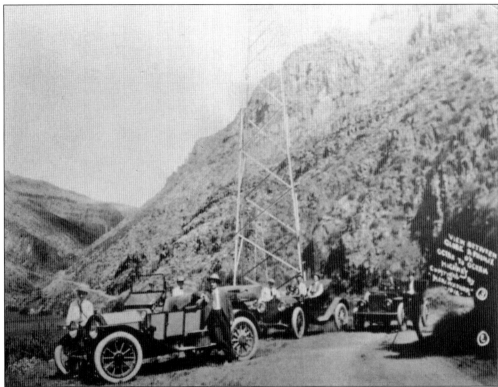

One of the first traffic jams appears to have occurred on this busy road sometime in 1912. Several motorists stopped to visit and pose for this photograph. (Courtesy SMHS, Gribble Collection.)

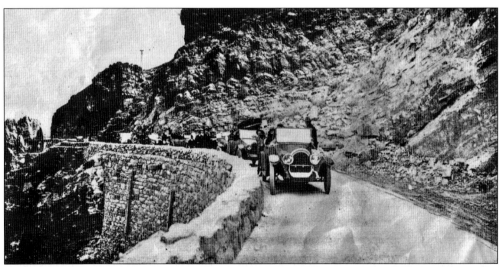

Is this another traffic tie-up? Actually this was an Oldsmobile tour in the 1910s to promote the new Model 45-A, eight-cylinder, seven-passenger touring car and the Apache Trail automobile tours. (Courtesy SMHS.)

This family appears to enjoy their c. 1910s Sunday drive along the Apache Trail. Note that this is the exact location of the photographs shown on pages 46 and 47. (Courtesy SMHS.)

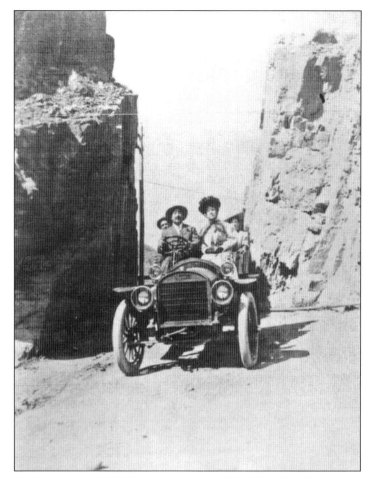

This group of Sunday drivers was well dressed for their tour down the Apache Trail. They stopped at the Fish Creek Lodge for a rest before continuing their journey. Note the Fish Creek Hill road grade to the left of the car. (Courtesy SMHS.)

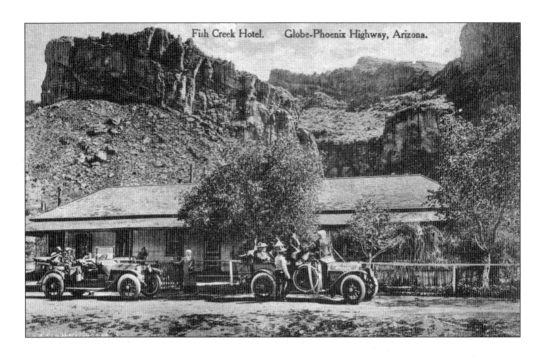

The Fish Creek Station was always a popular spot for travelers of the day. Unfortunately the Fish Creek Lodge burned down on January 5, 1929, and was never rebuilt. (Both courtesy SMHS.)

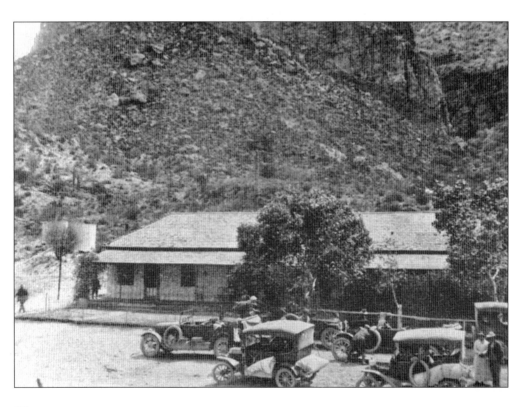

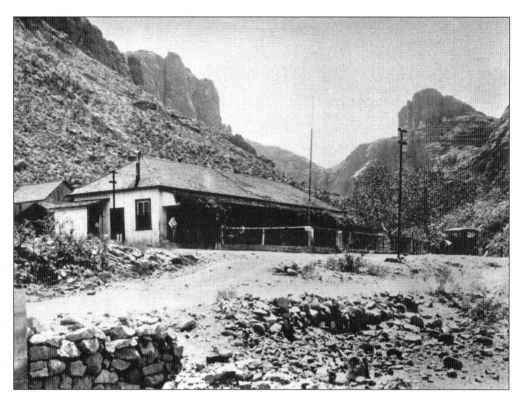

The Fish Creek Lodge was the best place to stop for a hot meal along the Apache Trail in the 1920s. (Courtesy SMHS.)

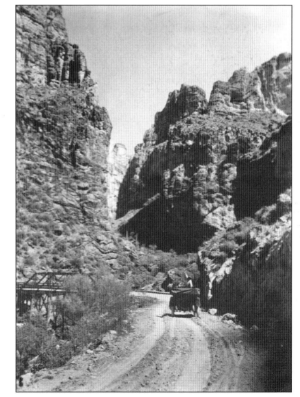

This motorist stops in the middle of the road to point to something at the bottom of Fish Creek Hill. At the lower left is the original Fish Creek timber bridge structure. A steel truss bridge was constructed by the Arizona Highway Department in 1923. (Courtesy SMHS.)

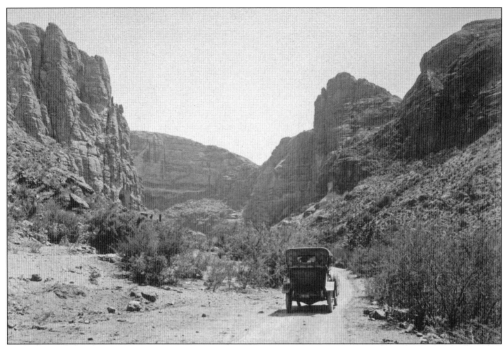

This motorist travels along the Apache Trail and enjoys the view near Fish Creek Canyon. The location of this portion of the Apache Trail is near Milepost 224. This vehicle is traveling westbound toward Phoenix. (Courtesy Bureau of Reclamation, Walter J. Lubken Collection.)

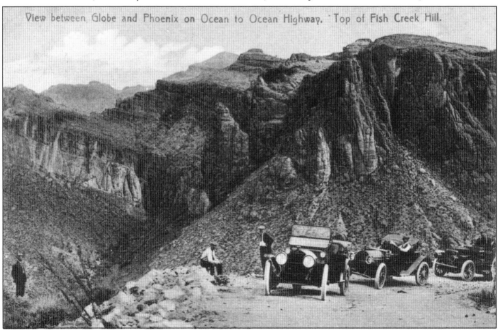

Panoramic views abound around every turn along the Ocean to Ocean Highway (Apache Trail). Travel along the trail was a challenge due to the shortage of gasoline and the rugged terrain. According to the *Arizona Democrat* of March 18, 1911, "The trip to Roosevelt is a hard one and only the best made machines can make the distance without trouble." (Courtesy SMHS.)

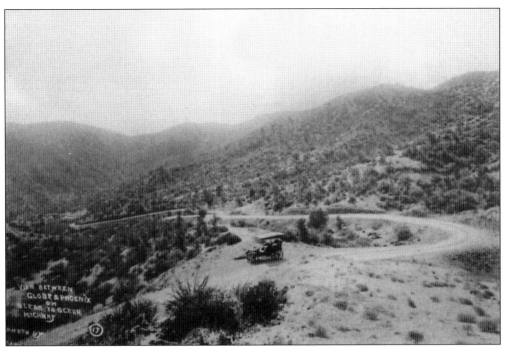

This Sunday driver stops to rest and enjoy the views along the Apache Trail in 1912. (Courtesy SMHS, Gribble Collection.)

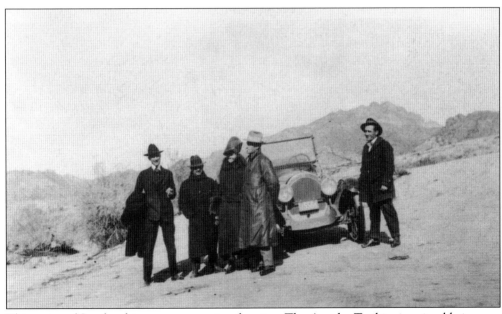

This group of Sunday drivers stops to enjoy the view. The Apache Trail is an enjoyable journey in the wintertime; at least the car will probably not overheat. (Courtesy SMHS.)

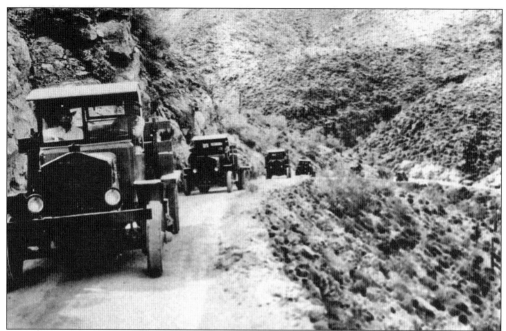

A convoy of Pearce-Arrow trucks carries supplies along the Apache Trail on its way to Theodore Roosevelt Dam. (Courtesy SRP.)

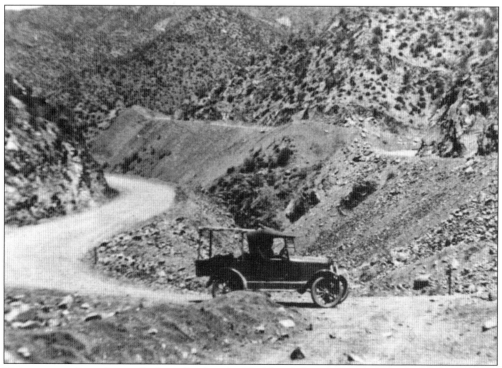

This motorist drives his truck along the Apache Trail headed to Roosevelt Lake. (Courtesy SMHS.)

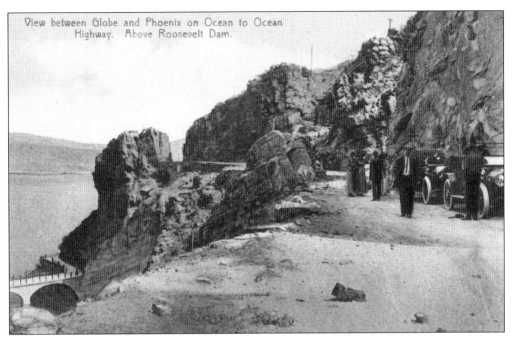

Several Sunday drivers stop to stretch along the Apache Trail above the dam. Everyone was well dressed for the occasion. This portion of the road was realigned as part of the Roosevelt Dam reconstruction project. The Bailey bridges shown on page 119 were in this general area. (Courtesy SMHS.)

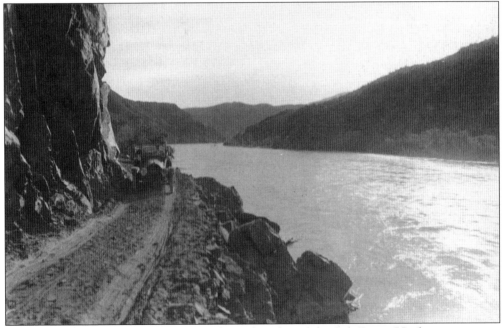

This motorist enjoys the scenic views along the edge of the Salt River. He does not appear concerned about the narrow road. This portion of the trail (mile markers 52–59) was flooded by the waters of Apache Lake upon completion of Horse Mesa Dam in 1927. (Courtesy SMHS, Southern Pacific Railroad photograph book.)

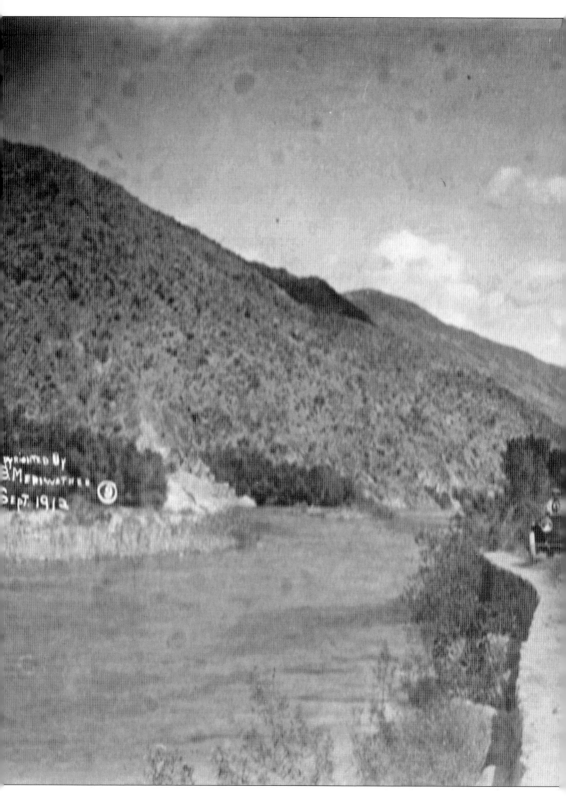

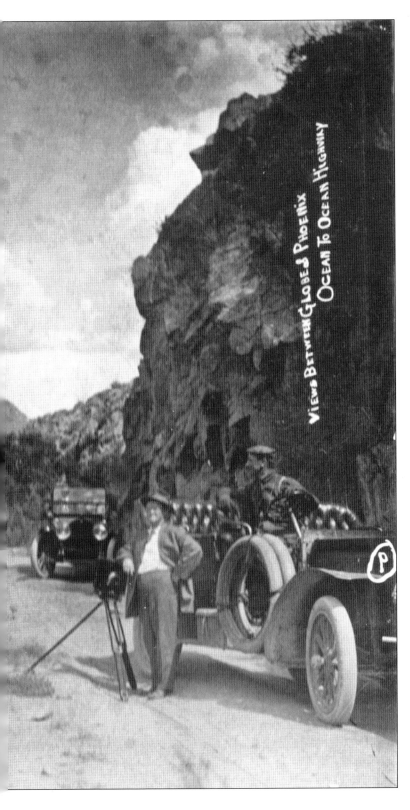

A photographer stops along the Apache Trail to capture the moment on film in September 1912. This portion of the road was flooded by the waters of Apache Lake in 1927. (Courtesy GCHSM, Gribble Collection.)

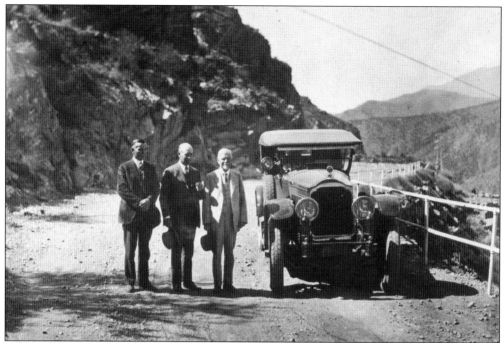

A group of motorists stops to enjoy the view near Roosevelt Dam and to shake off some of the dust. They were well dressed and gracious enough to pose for this photograph. (Courtesy Bureau of Reclamation, Walter J. Lubken Collection.)

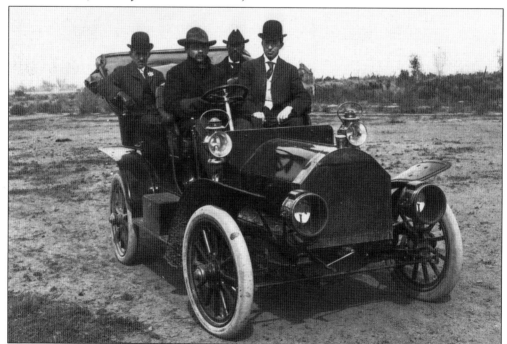

A group of finely dressed gentlemen has gone out for a Sunday drive along the Apache Trail. Note that the Sunday drivers were again well dressed for their trip, a common sight during that era. (Courtesy SMHS.)

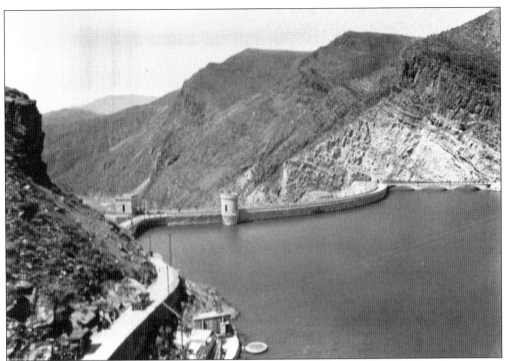

The road approaching the dam was a source of stress to the average driver and an adventure for everyone. This portion of the road has been abandoned. The new Roosevelt Bridge is located near this spot. (Courtesy SMHS.)

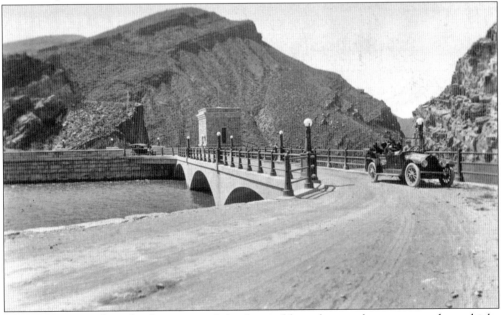

This motorist is relieved to have crossed the dam safely and not to have met another vehicle. Backing up along the road was a challenge, so most motorists learned to look well ahead to see if another vehicle was approaching from the opposite direction before proceeding across the dam. (Courtesy SMHS, Southern Pacific Railroad photograph book.)

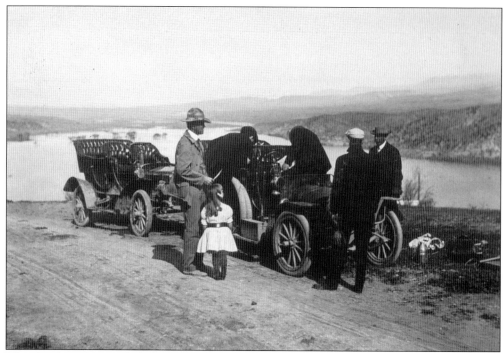

This family outing included a drive along the old Highline Road near Roosevelt Lake. One motorist stops to assist another who is experiencing mechanical difficulties. (Courtesy Bureau of Reclamation, Walter J. Lubken Collection.)

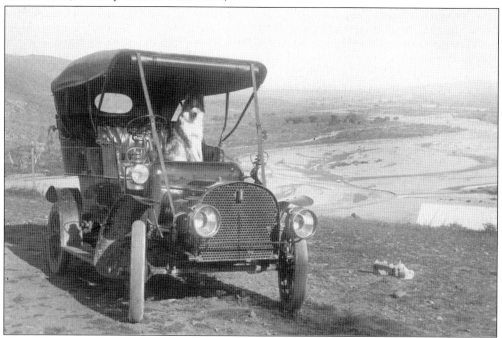

The view from the old Highline Road in 1907 shows the panoramic landscape before the lake filled with water. Some folks used to take their pets on Sunday drives. (Courtesy Bureau of Reclamation, Walter J. Lubken Collection.)

Four

Tourist Destination Apache Trail

Around 1916, the Southern Pacific Railroad began to promote the Globe to Roosevelt and on to Phoenix route, part of the Ocean to Ocean Highway, as a popular tourist automobile side trip called the "Sunset Route." The railroad introduced parlor cars, a modified autobus, to transport larger groups of tourists along the road. In an effort to entice customers and to add a touch of mysticism and lore, railroad marketers coined the famous name "Apache Trail," and the name has been associated with the road ever since. Since the railroad did not have a link from the Globe-Miami area to Superior and on to Phoenix, the side trip provided travelers the opportunity to take the train to Globe, ride down the Apache Trail in touring cars, and reboard the train in Phoenix for destinations westward. These trips were highly promoted and well attended until they were significantly impacted in 1927 by the flooding of the road described in the previous chapter. The railroad made a gallant effort to continue the tours, but the Great Depression eventually contributed to the end as money became scarce. Several other automobile touring companies provided regular service along the Apache Trail from both the Phoenix area and the Globe-Miami area during the same time period.

In April 1925, *Arizona Highways* magazine began as a trade journal, tourist promotion, and engineer's road condition report. Several articles have been published by *Arizona Highways* magazine on the Apache Trail; the first article appeared in the magazine's second issue, the May 1925 edition, as a four-page travelogue. The January 1928 edition describes the Apache Trail as "a graveled surface, 47 miles in length that could be driven in one and a half hours." The April 1928 edition by H. E. O. Whitman, entitled "Along the Apache Trail," was geared to promote tourism on the Apache Trail. Another article published in the May 1939 issue, entitled "The Apache Trail—Spectacular Scenicway," by Joseph Miller, described the breathtaking beauty of the road and provided one of the Apache Trail's early tourist guides. Even today, the Apache Trail is marketed as a tourist destination, and several guided tours are available to the public.

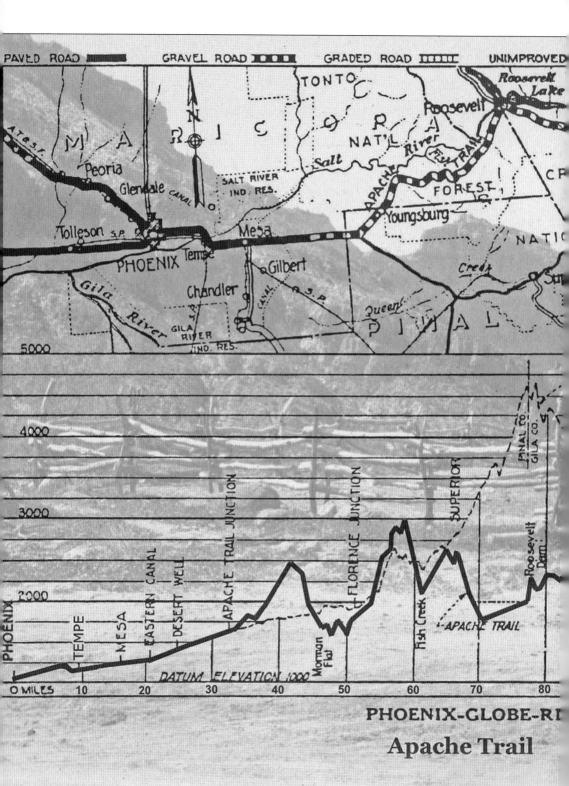

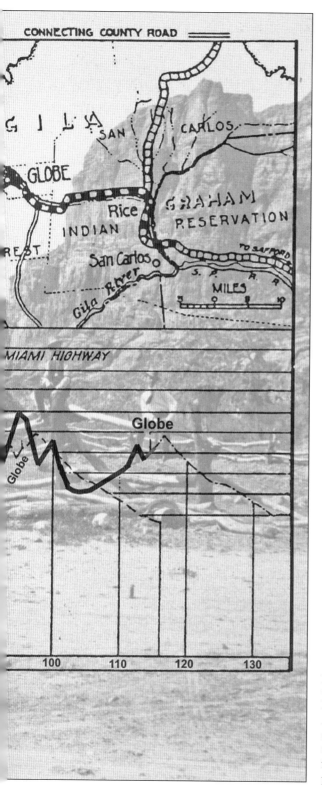

This 1924 map shows the Apache Trail and the newly constructed Superior-Miami highway. The road forked near present-day Apache Junction, leaving motorists their choice of travel. The vertical elevation profile of the Apache Trail (bold line) and the Superior-Miami highway (dashed line) lend themselves for comparison. The travel distance from Phoenix to Globe via the Apache Trail is 115 miles, while the distance along the Superior-Miami highway is 96 miles. In addition to being shorter, the Superior-Miami route has been significantly upgraded and provides the best route of travel. Several portions of the road have been converted to a four-lane divided highway, while several miles of the Apache Trail have remained narrow and unpaved. The scenery along both routes is spectacular. (Map redrawn from old ADOT reports; background photograph courtesy SMHS.)

The boom in tourism prompted the production of promotional brochures advertising the beauty of the Apache Trail as a travel destination. Both the Apache Trail and the Superior Highway were included in this publication. (Courtesy SMHS.)

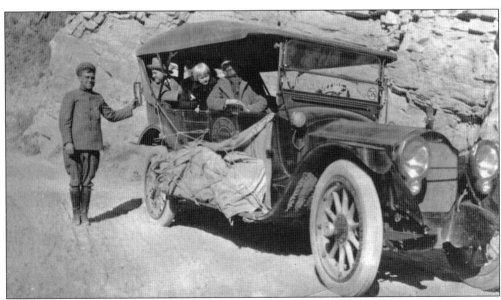

Automobile tours became popular around the year 1916. One of the first automobile tours was offered by the Phoenix-Globe Auto Stage Company. Here the driver poses for a picture; he probably stopped to change a flat tire. Note the Apache Trail Auto Tour logo on the door of the car. (Courtesy SMHS.)

This 1916 advertisement promoted tours offered by the Union Auto Stage Line, a company that operated regular tours from either Globe or Phoenix for $18 or through service for $10. (Courtesy Stan Gibson.)

Below is one of the original Union Auto Stage touring cars; this one bears the name "Apache Trail Phoenix-Globe-Miami" on the placard on the windshield. (Courtesy Stan Gibson.)

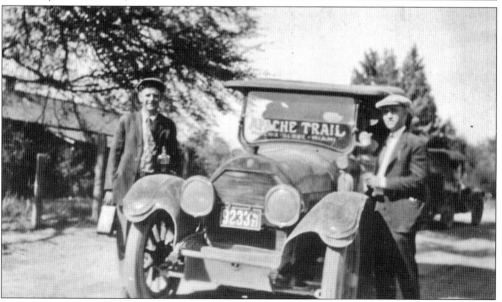

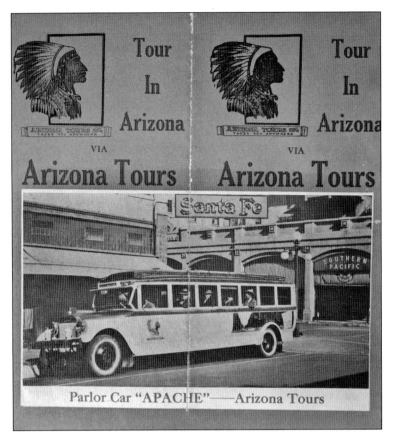

This brochure was published by Arizona Tours, Inc., in the early 1920s. A parlor car named "Apache" was used to take tourists down the trail. (Courtesy SMHS.)

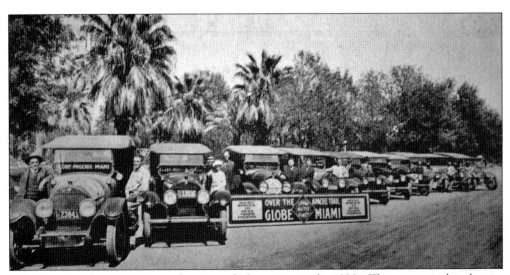

The Phoenix-Globe-Miami tour fleet is ready for action in the 1920s. These cars are lined up in Phoenix awaiting their turn to make the fabulous trip up the Apache Trail. (Courtesy SMHS.)

A touring car preparing to take tourists up the old Apache Trail is parked in front of the Union Auto Stage Company in Phoenix around the 1920s. (Courtesy Stan Gibson.)

The Shriners (below) took a tour of the Apache Trail c. 1920 on the way to their annual convention held in Los Angeles, California. (Courtesy Stan Gibson.)

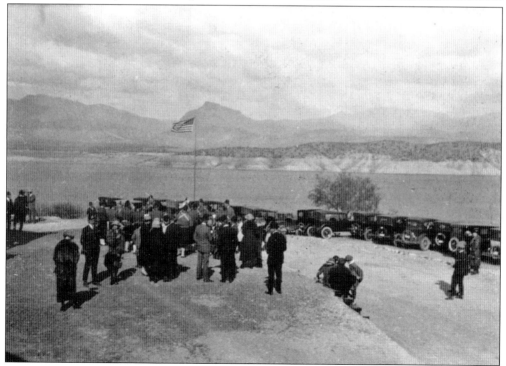

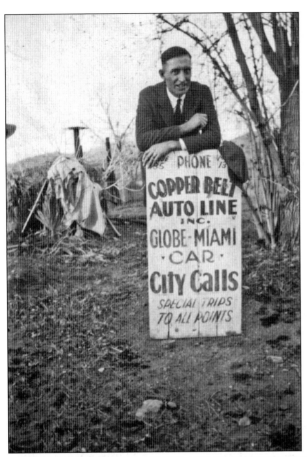

A driver for the Copper Belt Auto Line Company, which also provided trips along the trail by appointment only, poses for the camera *c.* 1919. (Courtesy Stan Gibson.)

This *c.* 1919 Union Auto Stage car is parked outside the Dominion Hotel on Broad Street in Globe, where passengers were picked up for their tour down the Apache Trail. (Courtesy Stan Gibson.)

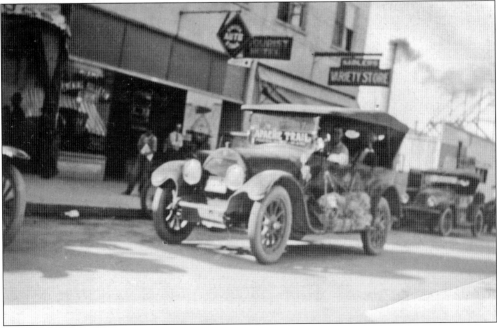

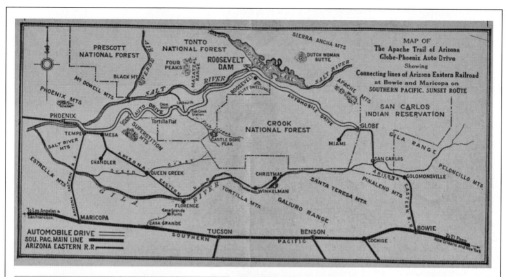
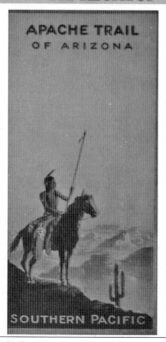
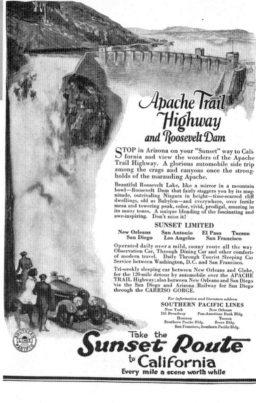

One of the biggest promotional campaigns began around 1916 with the Southern Pacific Railroad and their famous "Sunset Route" side trips along the Apache Trail. These tours were very popular until the 1930s, when the Great Depression caused money to become scarce. Shown above are several publications distributed by the Southern Pacific Railroad. (Courtesy SMHS.)

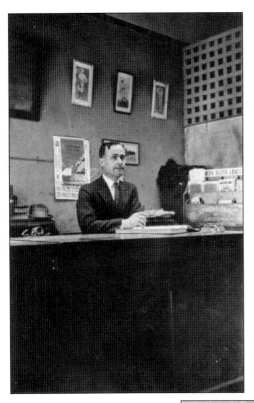

Jesse Gibson works at his desk at the Union Auto Stage station in Globe, 30 miles south of Roosevelt. His son, Stan Gibson, became mayor of Globe and ran a clothing store under the family name. Notice to his left are several brochures that are shown in this chapter. (Courtesy Stan Gibson.)

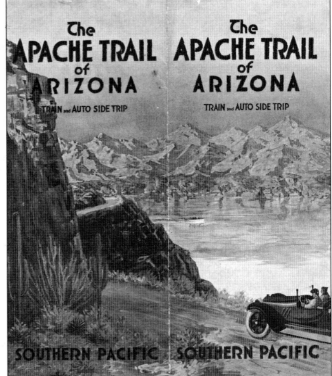

This brochure advertising the Apache Trail tour was popular in the 1920s. The Southern Pacific Railroad produced numerous versions of these brochures over the years to promote their combination train and Apache Trail side trips. (Courtesy SMHS.)

Shown in this photograph (above) are the drivers of the Globe Union Auto Stage Company in front of the Dominion Hotel in Globe. Jesse Gibson is the one in a suit holding a paper; the drivers' names are unknown. (Courtesy Stan Gibson.)

Another intriguing brochure (right) promoting the Apache Trail tour was produced in 1916. The experience of the Apache Trail is truly a story without words. Reported in the March 20, 1911, edition of the *Arizona Democrat*, Pres. Theodore Roosevelt made this comment when he dedicated the dam in March 1911: "I did not, or never realized until this morning what an extraordinary, beautiful picturesque strip of country life this is." (Courtesy SMHS.)

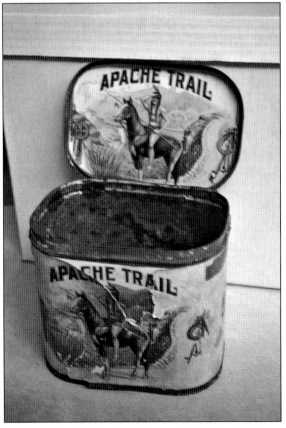

Marketing schemes thrived during the time period in the 1910s and 1920s when Apache Trail tours were popular. Apache Trail brand cigars were one of the items preferred. Above is the cigar band design, and at left is the tin cigar box with its original paper wrapping, which is quite rare. (Both courtesy SMHS.)

This Gibson family outing on the old Apache Trail occurred in 1938. In the photograph below, from left to right, are Stan Gibson's Aunt Lucy Nelson, mother Hazel, grandmother Ida Story, Stan, and his sister Betty Jean Skiles. (Both courtesy Stan Gibson.)

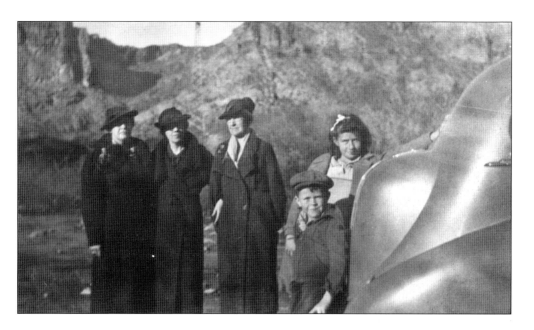

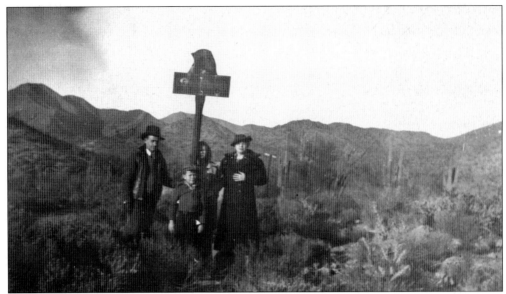

The Gibson outing included a stop at a place call Cactus Forest, a wide spot along the Apache Trail, marked only by this sign. This site was determined by the author to be near the Burnt Corral Campground area. (Courtesy Stan Gibson.)

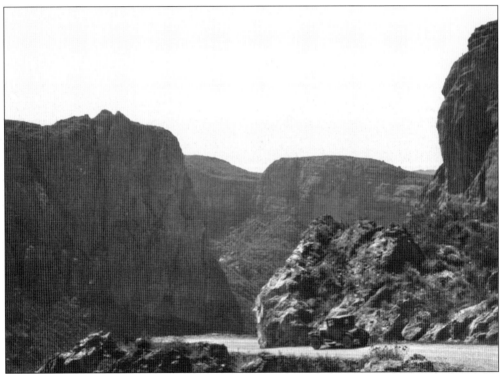

Travel along the Apache Trail was always an adventure, but it was an experience that left a lifelong impression on the soul. These adventurers approach the descent down Fish Creek Hill in 1927. (Courtesy ADOT.)

Tourists stop on top of the dam in 1915 to enjoy the view. The little girl is looking over the edge of the dam. Yes, it is a long way down, but she does not seem to be concerned. Although officially not part of the Apache Trail, the road on top of the dam provided excellent views of the lake on one side and the Apache Trail traversing the canyon on the other side. (Courtesy Stan Gibson.)

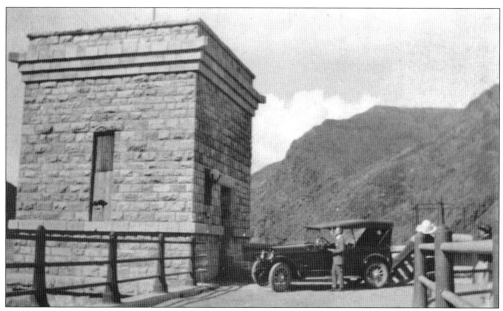

These motorists stop on top of the dam for a break. Certainly they are enjoying the spectacular views. (Courtesy SMHS.)

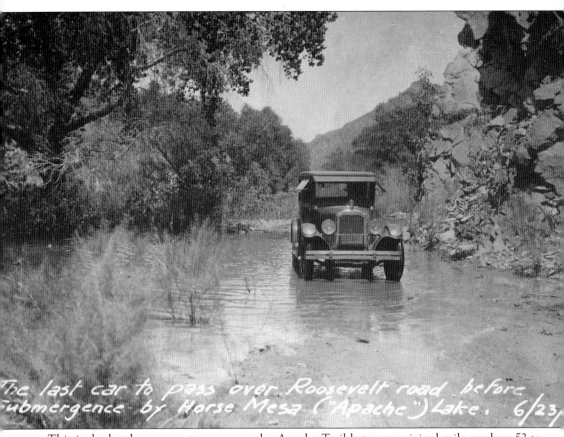

This is the last known car to pass over the Apache Trail between original mile markers 52 to 59 as the waters of Apache Lake inundated the road. This photograph was taken June 23, 1927. (Courtesy SRP.)

Five

A PERIOD OF CHANGE

Theodore Roosevelt Dam provides water for public use, electric hydropower, and flood control for Maricopa, Pinal, and Gila Counties. In an effort to provide improved safety, additional storage capacity, and better flood-control capabilities, the Bureau of Reclamation decided to upgrade the dam. Revised hydrological analysis determined the current cyclopean-masonry arch dam was not sufficient to handle the largest probable flood event. Overtopping of the dam would cause catastrophic damage to Horse Mesa, Mormon Flat, and Stewart Mountain Dams and downstream communities. In addition, it was determined that the existing dam was at risk if an extreme earthquake event occurred, and also the outlet structures were insufficient to empty the dam quickly in an emergency. Modifications to the dam included raising the original structure 77 feet to a total height of 357 feet, which began in February 1991 and was completed in January 1996. The original dam was significantly altered, resulting in a loss of its National Historic Landmark designation. As part of the dam reconstruction, the Apache Trail was subject to frequent and extended closures. This caused even less public interest in using the road. The dam modification required significant reconstruction of the roads in the vicinity of the dam. The Apache Trail was reconstructed from the new intersection with State Route 188 to the power plant access road at a cost of $11 million. The road across the top of the dam was buried in tons of concrete. A new, $21.3 million, 1,080-foot-long, steel-arch bridge—the longest two-lane single-span structure in North America when constructed—was built by ADOT to carry traffic across the lake. As ADOT's district engineer at the time, this author signed the request to abandon the old road across the dam to Reclamation. Visitors can still see abandoned sections of these old roads if the lake level is low.

This motorist has stopped to enjoy the spectacular view of Canyon Lake along the Apache Trail. (Courtesy SMHS.)

The views from the Apache Trail to portions of Apache Lake are breathtaking (below). (Courtesy SMHS.)

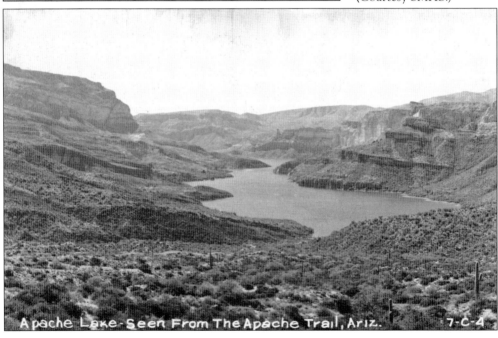

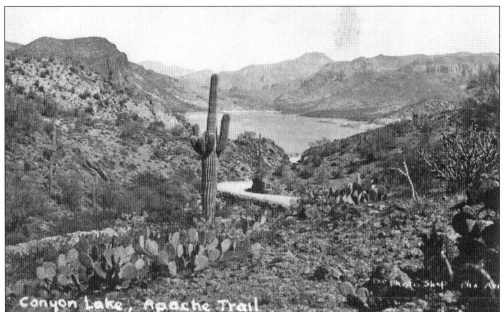

This spectacular view of Canyon Lake (above) is one of the many afforded to the traveler around every turn on the Apache Trail. (Courtesy SMHS.)

An Arizona Highway Department truck hauls material along the Apache Trail c. 1933. (Courtesy ADOT.)

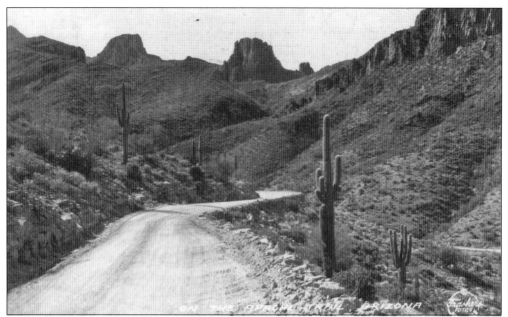
The serene character of the road in the 1930s is evident here, with its fairly narrow width, unpaved surface, and scenic vistas. (Courtesy SMHS.)

This photograph shows some of the preliminary paving (road oiling) efforts by the Arizona Highway Department. The first road oiling occurred in 1929 from Mesa to Gilbert Road. Full-scale paving occurred in 1949 from Apache Junction to Goldfield. The paving progressed toward Roosevelt, with the last section of pavement placed in 1961 from mile marker 218 to 220. From mile marker 220 to 242, the Apache Trail remains a gravel surface road. (Courtesy SMHS.)

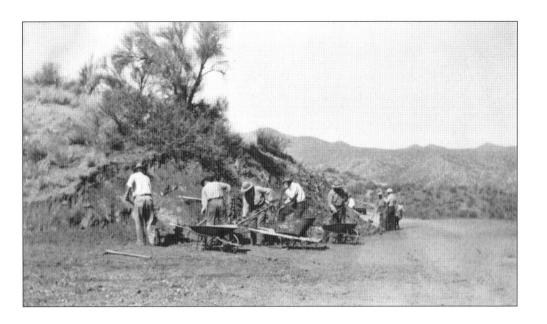

The Arizona Highway Department utilized WPA workers in the 1930s to complete road improvement projects. Here a WPA crew is working on the slopes of the Apache Trail road north of Globe in 1936. (Both courtesy Angela Antilla.)

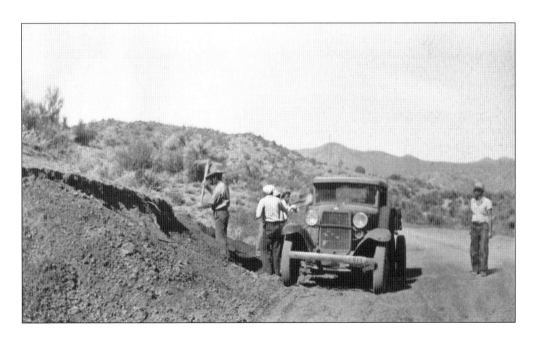

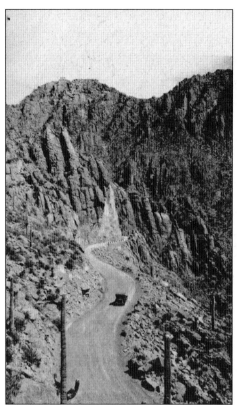

The Apache Trail would soon be replaced by a modern new highway in 1922, future U.S. Highway 60. The Superior-Miami highway was pushed by the mining communities of Globe and Miami in the early 1910s, with the support of Gov. George W. P. Hunt. Funding was approved and construction completed between 1917 and 1922. The new road was deemed the "Million Dollar Highway." The dirt road wound through Queen Creek Canyon as shown here. (Courtesy SMHS.)

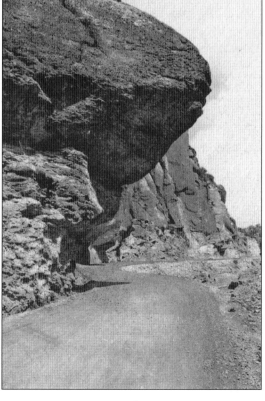

Even with advanced engineering techniques, only so much could be accomplished. Though this was likely an aesthetic approach, trucks probably did not like it very much. One of these rock spires was blasted away in 1996, resulting in a two-day closure of the road. (Courtesy SMHS.)

The new Superior-Miami highway passed through some of the most rugged country in Arizona. Innovative engineering techniques such as tunneling were employed to traverse the challenging terrain. Also, in an effort to reduce costs of construction, the Arizona Highway Department utilized convict laborers to build portions of the road. The old prisoners road camp was located in Queen Creek near the large water tank outside of Superior. The old tunnel was named Claypool Tunnel in honor of Sen. W. D. Claypool. (Both courtesy GCHSM.)

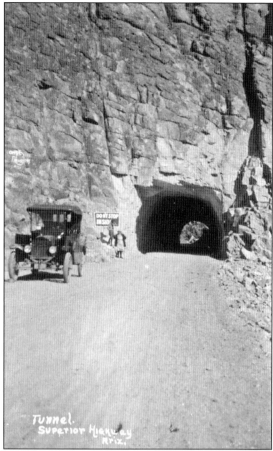

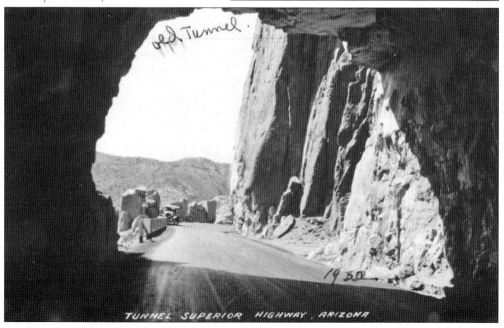

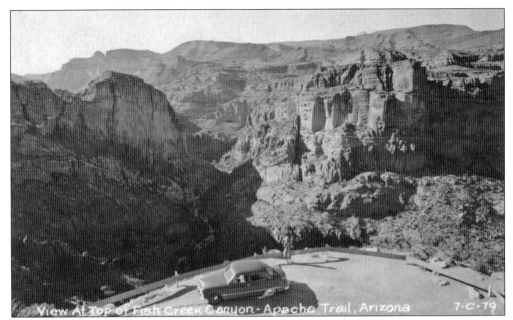

Another satisfied Apache Trail traveler stops to enjoy the view at the top of Fish Creek Canyon. (Courtesy GCHSM.)

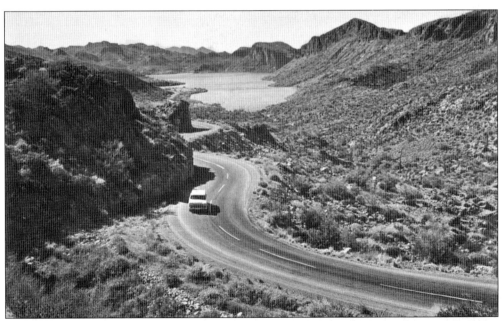

Motorists enjoy a segment of nice, smooth, paved road near Canyon Lake, no doubt a relief after the previous rough gravel surface. (Courtesy SMHS.)

Ascending the infamous Fish Creek Hill in 1969 no doubt gave this motorist a white-knuckle grip on the steering wheel. Notice the guard rail along the left side of the road. This guard rail design is called "Resiliflex Road Guard," patented in 1931 by engineer Eugene Vernon Camp. It consists of a flexible-type, smooth-surface, resilient plate-guard rail attached to posts anchored in the ground. (Courtesy ADOT.)

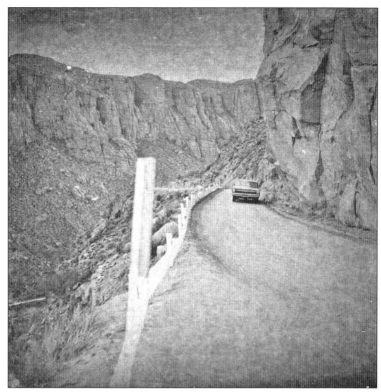

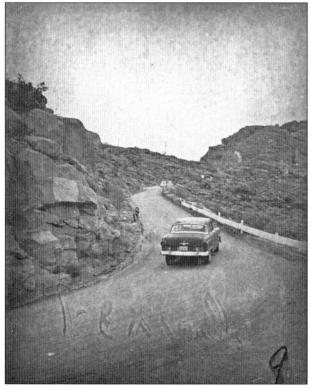

This motorist appears to be the king of the road as he is taking his half out of the middle of the trail. (Courtesy ADOT.)

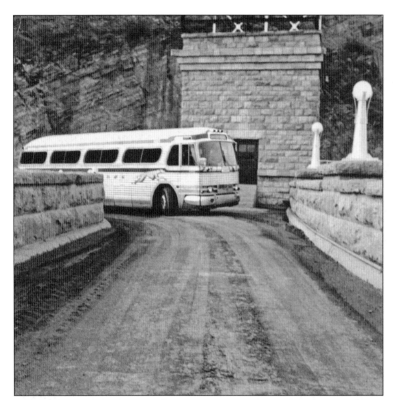

A Greyhound bus attempts to make the turn to go across the dam in 1958. The only problem is this is the first trip across the dam for the new bus driver. After several attempts, a few good laughs, and a stretch break, the Globe Chamber of Commerce members were able to make it to Payson to meet with their chamber. They returned safely with the same driver. (Courtesy Stan Gibson.)

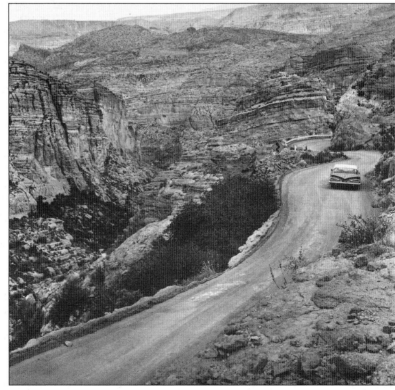

A 1959 Chevy descends Fish Creek Hill. (Courtesy SRP.)

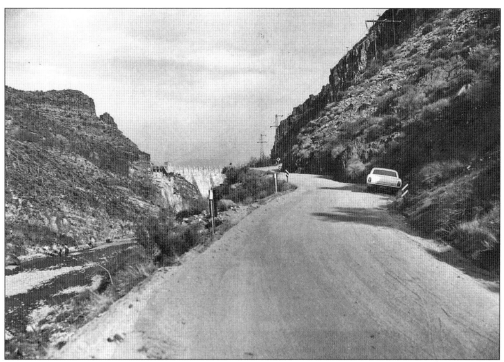

A vehicle travels the Apache Trail near Roosevelt Dam in 1970. (Courtesy SRP.)

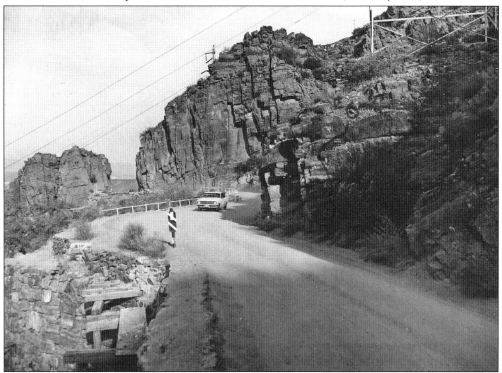

In 1970, travelers still enjoyed the lore of the Apache Trail. Note the gap cut toward the left of the photograph. This is the same spot shown on pages 46 and 47 and the top of page 67. (Courtesy SRP.)

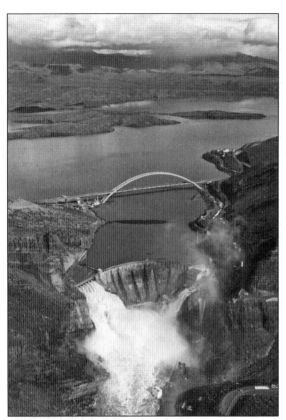

A stunning aerial photograph shows the new 1,080-foot-span steel-arch bridge at Roosevelt Lake, constructed by ADOT for $21.3 million and dedicated in 1990. Note the excess water flowing through the spillway during this 1993 flood event. (Courtesy Bureau of Reclamation.)

The flooding in 1993 caused significant damage to the Apache Trail downstream of the dam. ADOT has bladed a berm to divert motorists away from the damage and has posted someone on-site to monitor the situation to ensure public safety. (Courtesy ADOT.)

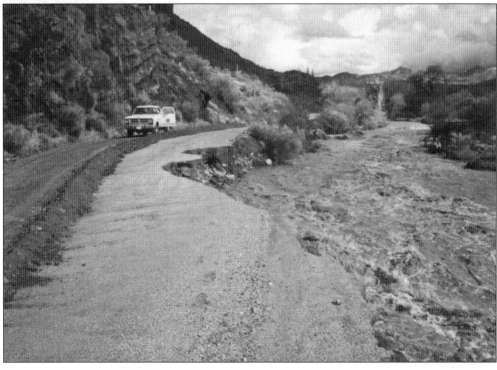

This 1972 aerial photograph shows the area near the dam prior to the Roosevelt Bridge being constructed. In the 1990s, the Bureau of Reclamation decided to raise and reinforce the dam. The road to Tonto Basin would be removed from along the top of the dam, and traffic would cross the new bridge. (Courtesy ADOT.)

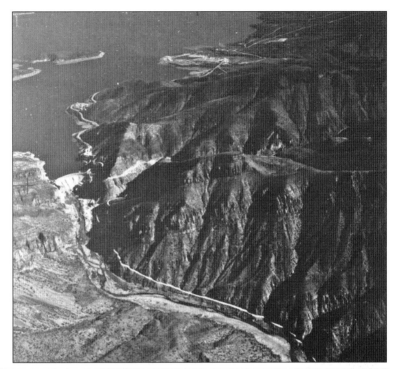

The upgraded dam nears completion around 1995. Reclamation added an additional 77 feet of height to provide more flood protection and increase storage capacity by over 300,000 acre-feet. Shown standing near the middle of the photograph is Reclamation's resident engineer for the project, John Wilke. (Courtesy Bureau of Reclamation.)

The new improved Roosevelt Dam was rededicated on April 12, 1996, eighty-five years after being dedicated by Theodore Roosevelt. (Courtesy Bureau of Reclamation.)

Former Arizona governor Fife Symington delivers a speech at the rededication ceremony in 1996. (Author's collection.)

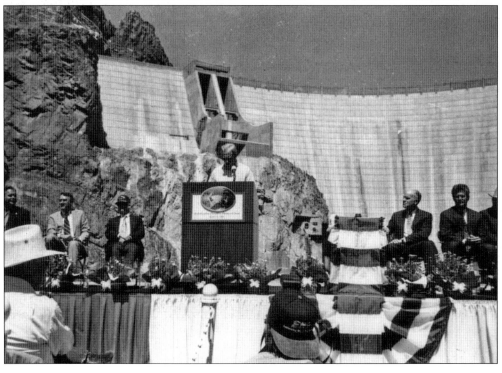

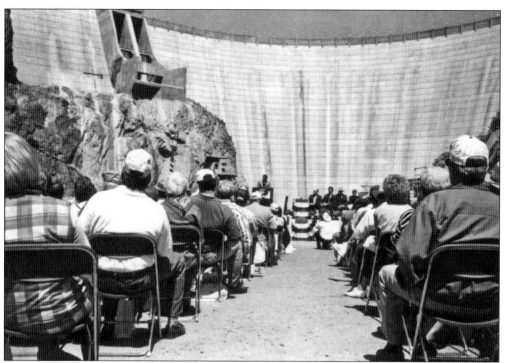

Attendance at the rededication ceremony was limited because of space constraints. The ceremony was held below the dam, not on top as was done in 1911. (Author's collection.)

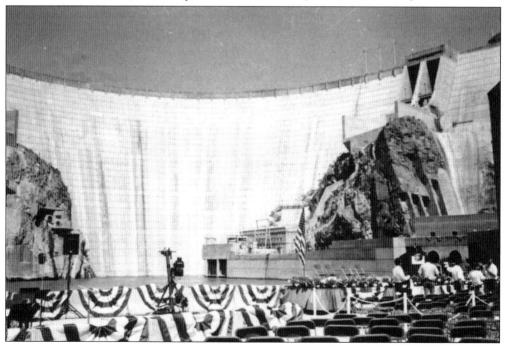

The newly completed Roosevelt Dam stands a towering 357 feet, 77 feet higher than the original dam. It was reconstructed by contractor J. A. Jones in nine years at a cost total of $450 million. (Author's collection.)

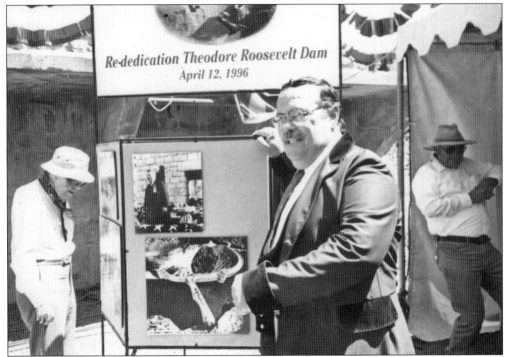
Even Teddy Roosevelt showed up for the rededication ceremony . . . or at least his Hollywood double was able to stand in for him. (Author's collection.)

Author Richard L. Powers was fortunate enough to attend this event. Here he poses with former Globe mayor David Franquero on the right. (Author's collection.)

Six
MODERN-DAY APACHE TRAIL

Eventually the historic mysticism of this road was revived, and efforts were made to preserve the rustic feel of the Apache Trail. In recognition of this effort, the Arizona Department of Transportation designated the Apache Trail (milepost 201–242.5) as the state's first historic road on June 20, 1986, with the passage of Resolution 86-06-C-45 by the Arizona State Transportation Board.

The Apache Trail provides access to recreational opportunities, including Canyon Lake, Apache Lake, Roosevelt Lake, scenic vistas, and various campsites along the way. Since the reconstruction of Theodore Roosevelt Dam and significant improvements to U.S. Highway 60, the Apache Trail has settled back into a relaxed lifestyle. Today the Apache Trail is not used to deliver major supplies to the dam; however, it is still a destination for the adventurous tourist.

In the late 1990s and early 21st century, the Arizona Department of Transportation built a new highway from Roosevelt to Globe. The highway replaced the old Highline and Apache Trail alignment and was renumbered State Highway 188. On March 9, 2004, the highway was officially renamed "Senator 'Bill' Hardt Highway" by the Arizona Department of Transportation because of his strong support of this improved road between Globe and Roosevelt. The Apache Trail from Apache Junction to Roosevelt retained its original State Route 88 designation and famous name. The Arizona Department of Transportation initiated a cooperative working agreement with Federal Highways Administration Arizona Division and the Tonto National Forest Service in the late 1990s. One of the major focal points was the future of the Apache Trail. Several studies were conducted and operational goals for the road established. The main focus areas included size and weight of vehicles using the road, the remote nature of the road, diminishing surfacing materials pits, drainage and flooding, the condition and preservation of historical features, traffic safety, public safety enforcement, and potential future capital improvements.

The following operational and planning philosophy regarding the Apache Trail was jointly developed: "the primary function of the Apache Trail is for historic, scenic, recreational and tourism related purposes. The route is not designed for excessive loads or vehicles longer than 40 feet. The primary intent is to preserve the historic nature and character of the route, not develop it into a super highway."

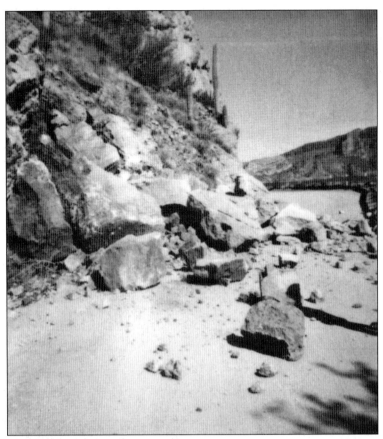

The modern-day Apache Trail requires significant maintenance to address a variety of issues, such as rock slides. Both photographs are along the Fish Creek Hill section of the trail. (Both courtesy ADOT.)

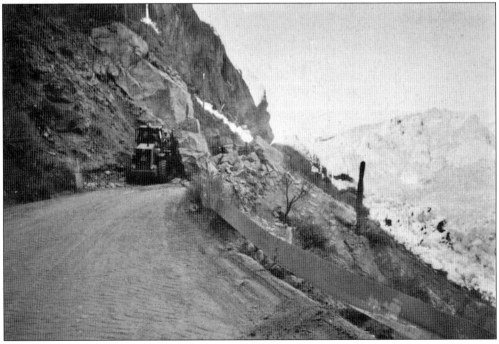

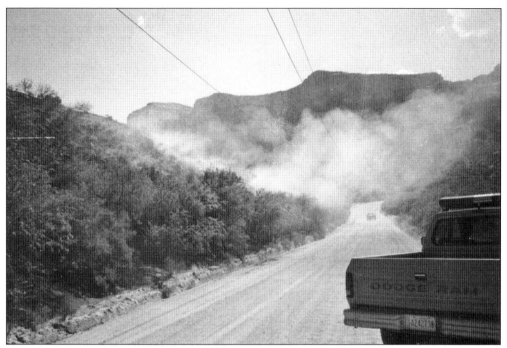

Another challenge that causes potential closure of the Apache Trail is forest fires. (Courtesy ADOT.)

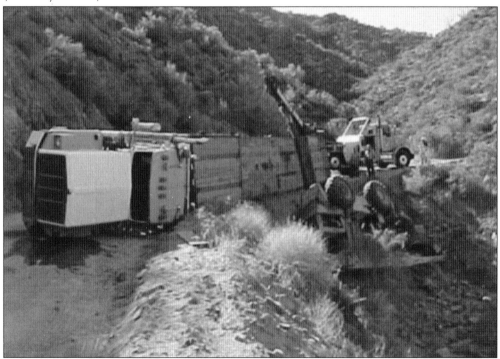

The Apache Trail has many twists and turns. Sometimes large trucks have difficulty negotiating the tight curves, resulting in accidents that close the road for short periods of time. (Courtesy ADOT.)

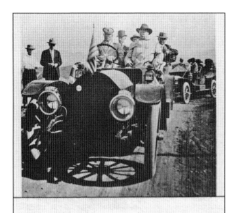

You are cordially invited to attend
the dedication of the Apache Trail
as an Arizona Historic Road.

The dedication will commence at 1:30 p.m.
Wednesday, February 25, 1987
at Lost Dutchman State Park
(located five miles north of Apache Junction
on State Route 88).

The Apache Trail is the first road
to be designated as a historic road in Arizona.

City of Apache Junction The Apache Junction Chamber of Commerce

The Apache Trail became Arizona's first official state-designated historic road on June 20, 1986. This is the official invitation to the dedication ceremony, held February 25, 1987. The effort to have the historic designation for the trail was championed by the City of Apache Junction and the Apache Junction Chamber of Commerce. (Courtesy SMHS.)

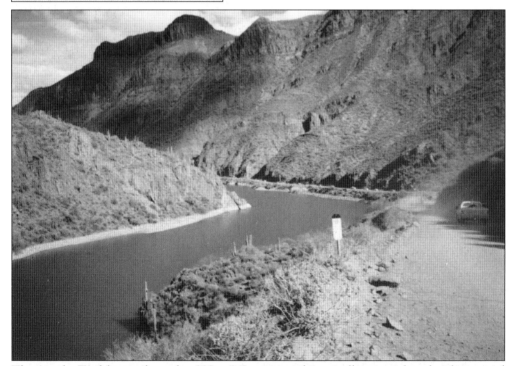

The Apache Trail from mile marker 220 to 242 remains a historically oriented road with unpaved surfaces and few modern engineering upgrades. This approach retains the historic feel and character of the road. (Author's collection.)

According to the *Arizona Republican* on April 27, 1905, the road was officially opened on April 24, 1905, and was 63 miles long. In 2005, the Apache Trail celebrated its 100th birthday. At right is the invitation to the centennial dedication ceremony. Below, several dignitaries and historical society members were present to cut the ribbon on October 7, 2005, at the Superstition Mountain Museum. Gov. Janet Napolitano and Pinal County supervisor Sandie Smith are shown at the center of the photograph next to the bow. Governor Napolitano is holding the large scissors. (Both courtesy SMHS.)

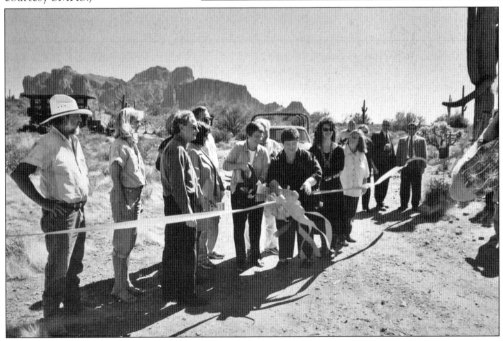

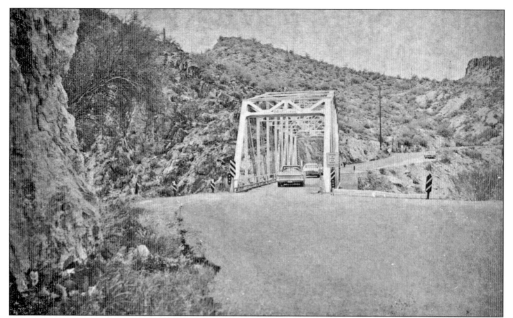

When the state assumed ownership of the Apache Trail in 1922, the Arizona Highway Department began to replace several structures. The old timber structures were replaced with steel or concrete bridges. This 1969 photograph shows First Water (Willow Creek) Bridge, located near mile marker 209.2, a 160-foot-long, 9-panel camelback-through truss structure completed in 1924. (Courtesy ADOT.)

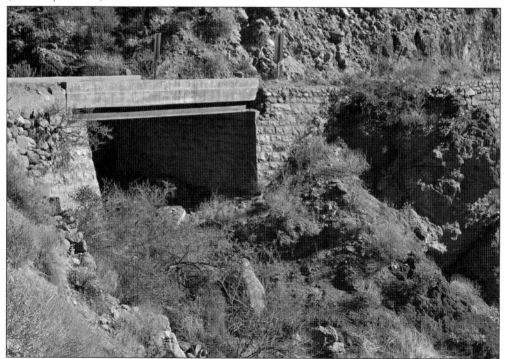

Dry Wash Bridge, located at mile marker 225.5, is a 32-foot-long, single-span, steel, multi-beam structure built in 1928. (Courtesy ADOT.)

At right above, the longest structure on the Apache Trail is the 488-foot-long Parker and Pratt steel-through truss bridge crossing Boulder Canyon (La Barge Creek) near mile marker 211. Segments of this bridge are spans that were recycled from old Wickenburg Bridge over the Hassayampa River, northwest of Phoenix. Originally constructed in 1920, this bridge was upgraded in 1937 when the trusses from the old Wickenburg Bridge were combined with the existing structure, saving thousands of dollars in construction costs. At right below, the Lewis and Pranty Creek Bridge near mile marker 224.6 was constructed in 1923 by contractor L. C. Lashmet with Fish Creek Bridge. Fish Creek Bridge is 74 feet long, and Lewis and Pranty is 59 feet long. (Both courtesy author.)

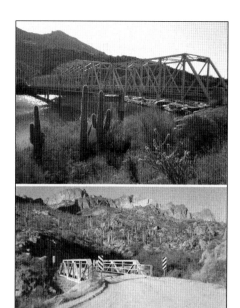

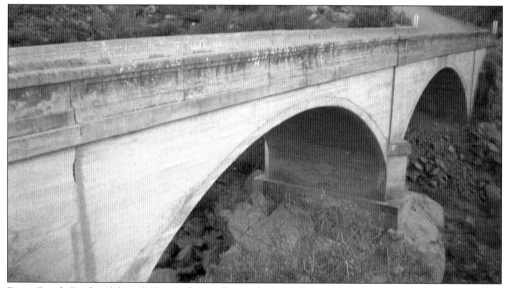

Pine Creek Bridge (above), located at mile marker 233.5, is a unique structure constructed in 1925. It was designed by the Arizona Highway Department (AHD) as a two-span, open-spandrel concrete Luten-arch bridge. AHD followed the bridge design patented by engineer Daniel B. Luten. In order to save money, this bridge was not contracted for construction, but built completely by AHD, utilizing "force account" laborers (temporary hourly wage workers). Davis Wash Bridge (not pictured) near mile marker 231.7 is a 3-span, 76-foot-long, continuous concrete-slab bridge built in 1939. The oldest structure on the Apache Trail is the Alchesay Bridge near mile marker 241.4, completed in 1905 (see photograph at top of page 57). This is a 22-foot-long, single-span, concrete-arch bridge and one of the last completed during the original construction. This bridge, still in place today, is the only original unaltered structure left from the trail's construction in 1905. (Courtesy author.)

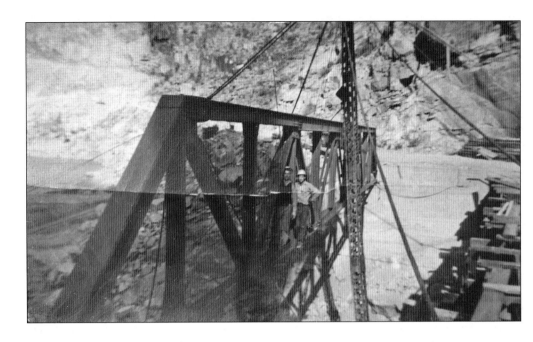

Above, Fish Creek Bridge is under construction in early 1923. Both the Fish Creek and Lewis and Pranty structures are single-span, riveted Warren pony trusses. Below, Fish Creek Bridge remains a single-vehicle structure in about 1969 and today. The image on the bottom left shows the original timber bridge that was replaced by the current steel bridge at bottom right. (Above, courtesy SMHS; below left, courtesy SMHS; below right, courtesy ADOT.)

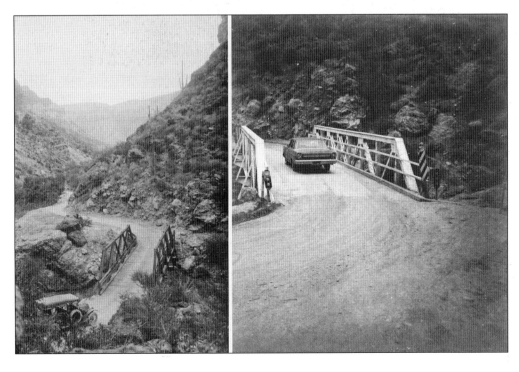

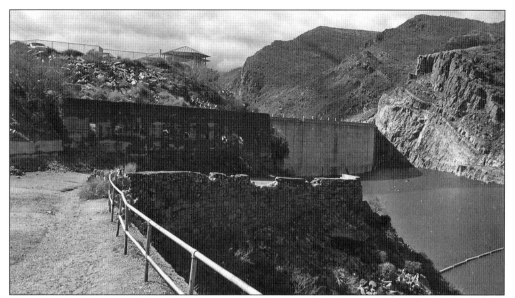

This abandoned section of roadway was removed from service after completion of the 1996 dam modification improvements. This is the area shown under construction at the bottom of page 24. (Author's collection.)

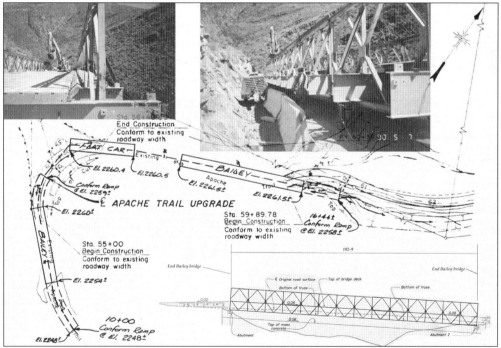

During the reconstruction of the dam, the Apache Trail was closed for significant periods of time. In order to maintain access for construction equipment and traffic, "Bailey Bridges" were used for temporary spans by Reclamation. After completion of the dam, these temporary bridges were removed and bulk mass concrete was placed to fill the voids, as shown above. The insets show one of the Bailey Bridges being installed. (Drawing courtesy Bureau of Reclamation; photograph courtesy Tom Kent.)

119

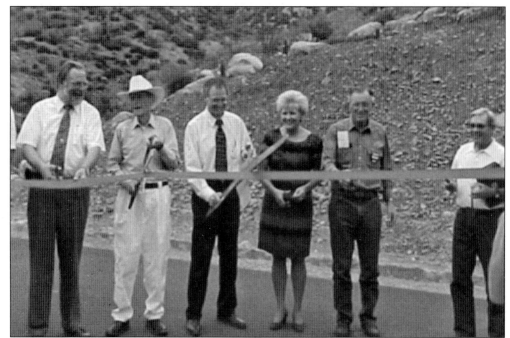

On September 10, 1999, the new State Highway 188 was dedicated. From left to right, State Transportation Board chairman Ingo Radicke, Arizona senator Bill Hardt, Richard Powers, Arizona Department of Transportation director Mary Peters, Governor's Office representative Brent Brown, and Gila County supervisor Joe Sanchez were present to cut the ribbon. The Apache Trail from Roosevelt Lake to Globe was completely replaced and renumbered by this new highway by 2006. (Author's collection.)

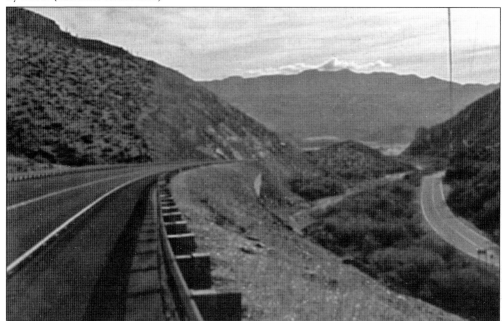

This view near the location of the dedication ceremony shows the old Apache Trail to the right and the newly constructed State Route 188 to the left. (Author's collection.)

In early 2006, Horse Mesa Dam was undergoing repair and the water level in Apache Lake was significantly lowered. Many people took the opportunity to walk along the original Apache Trail that was abandoned and flooded in 1927. The width was as narrow as the early photographs showed; the road appeared in fairly good condition except for a few rock slides, especially for having been submerged for approximately 79 years. (Both author's collection.)

The rock retaining walls along the edges appear much as they did when originally constructed. ADOT took the opportunity to conduct special field investigations to learn how the road and walls were originally constructed. (Author's collection.)

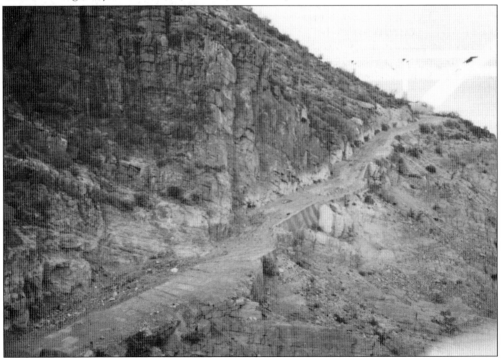

Another abandoned segment is shown here just east of the dam. (Courtesy ADOT.)

This pulley system was spotted during a hike in 2006 on the roadway. According to Gregory Davis of the SMHS, this was an old mining cable system to transport ore from an abandoned mine across the Salt River to be loaded on trucks. (Author's collection.)

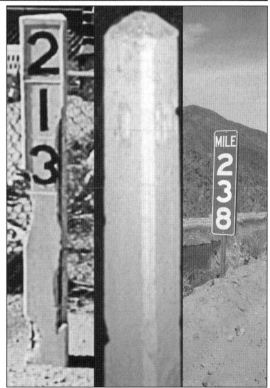

The leftmost old mile marker was in front of the old ADOT Fish Creek maintenance yard; however, this mile marker 213 was moved here from the Tortilla Flat area. The original zero marker shown in the middle is on display in the Arizona Historical Society Museum at Papago Park. The current mile marks, on the far right, are green with white numerals; the locations were adjusted by the Highway Department to meet state and federal standards. The map on pages 12 and 13 show their current location. An interesting note: There is no mile marker 217 on the trail due to some realignments without adjusting the markers. (Author's collection.)

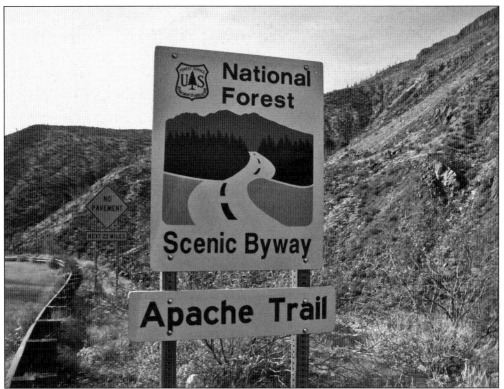

In addition to being designated a state historic road, the Apache Trail has also been designated as a National Forest Service Scenic Byway. (Author's collection.)

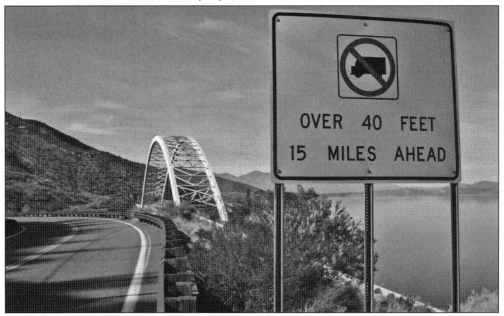

As depicted in previous photographs, the trail's narrow width and sharp curves can be challenging for 18-wheelers to negotiate. In the 1990s, ADOT restricted the size and weight of vehicles allowed to travel the Apache Trail. (Author's collection.)

In an effort to reduce maintenance costs and fugitive dust on the Apache Trail, ADOT began experimenting with polymer binders to provide a more durable surface while maintaining the rustic, historic feel of the road. (Courtesy ADOT.)

The Tonto National Forest has constructed several scenic rest stop vistas along the Apache Trail; this one is located near Canyon Lake. They also have facilities at the top of Fish Creek Hill, below the dam, and above the dam overlooking the dam, the lake, and the arch steel bridge. (Courtesy author.)

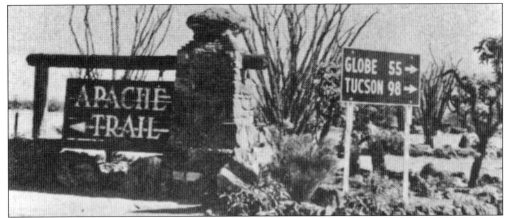

This vintage sign was located in Apache Junction where the road split. Unfortunately, these signs no longer exist. The date of this photograph is unknown. (Courtesy SMHS.)

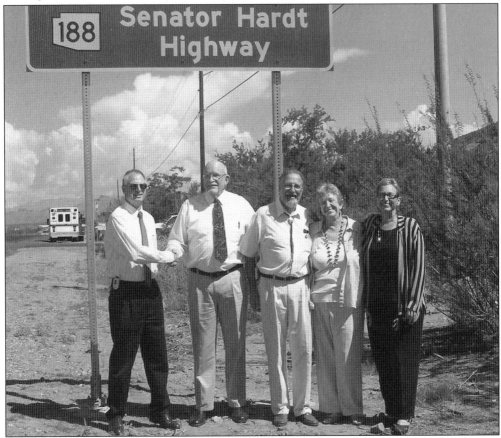

On March 9, 2004, State Route 188 was officially renamed "Senator Hardt Highway" in honor of the late senator A. V. "Bill" Hardt. This photograph taken August 23, 2006, was of the final completion of the new highway and the official unveiling of the Senator Hardt Highway signs. From left to right are author Richard Powers, the late former ADOT deputy state engineer August V. Hardt (the senator's son), former State Transportation Board chairman Ingo Radicke, and Kathryn Elowitz and Athia Hardt (two of the senator's daughters). (Courtesy Ingo Radicke.)

BIBLIOGRAPHY

Arizona Department of Transportation. Various reports, maps, and documents.
Kollenborn, Tom J. *Apache Trail: a Storybook Guide to Arizona's Historical Highway.* Apache Junction, AZ: Superstition Mountain Press, 1995, 2006.
Rogge, A. E., et al. *Raising Arizona's Dams.* Tucson, AZ: The University of Arizona Press, 1995.
Salt River Project. *Building a Legacy: the Story of SRP.* Self-published.
Zarbin, Earl A. *Roosevelt Dam: A History to 1911.* Phoenix, AZ: Salt River Project, 1984.

AUTHOR BIOGRAPHY

Richard L. Powers, P. E., was born in 1957 and grew up in eastern Kansas. He moved to Arizona in 1976 following his high school graduation and attended Arizona State University. He returned to Kansas for a short period of time, where he received his bachelor's degree in civil engineering from the University of Kansas. Powers later received a master's degree in civil engineering from Arizona State University. After starting to work for the Arizona Department of Transportation, he became interested in Arizona history. He has studied Arizona history and transportation history and has given numerous presentations throughout the state. He is a member of the Boy Scouts of America, has hiked the backcountry throughout the state, and has experienced some of Arizona's history firsthand. He retired from ADOT in 2007 and is working part-time for Jacobs in Phoenix. He is a member of the Arizona State Historical Society, the Gila County Historical Society Museum, and Rotary International.

Powers's introduction to the Apache Trail was in late 1993 during a trip along the road. He was amazed by the scenic beauty and primitive nature of this scenic byway and developed a keen interest in the road's historic past. Since that time, he has had the privilege of working with numerous colleagues studying this unique road. Hopefully you learned some interesting information and history about the old Apache Trail in this Images of America book.

Across America, People are Discovering Something Wonderful. Their Heritage.

Arcadia Publishing is the leading local history publisher in the United States. With more than 4,000 titles in print and hundreds of new titles released every year, Arcadia has extensive specialized experience chronicling the history of communities and celebrating America's hidden stories, bringing to life the people, places, and events from the past. To discover the history of other communities across the nation, please visit:

www.arcadiapublishing.com

Customized search tools allow you to find regional history books about the town where you grew up, the cities where your friends and family live, the town where your parents met, or even that retirement spot you've been dreaming about.